a scottish painter and his world
GORDON GUNN

Neil Rhind

Impulse Books

Aberdeen 1972

First published 1972 by
IMPULSE PUBLICATIONS LTD.
28 Guild Street,
Aberdeen, AB1 2NB.

Text
© Neil Rhind 1972

Pictures
© Gordon Gunn 1972

The text of this book has been printed
on Archive Tent supplied by P. F. Bingham Ltd. of
Croydon – a specially developed paper with a guaranteed
life of 500 years.

Printed in Scotland by Holmes McDougall Ltd., Aberdeen.

FOREWORD

GORDON GUNN, the subject of this book, is a Scottish painter whose work has become widely known in the past few years. This book was not written as a definitive account of his life and work, nor does it attempt to be a critical evaluation of his paintings and his particular rôle in modern painting. It is an interim account of the life and work of a friend. An assessment of a creative artist in a world that is not always kind to men who choose to take their own path through life.

This is how I see the life and work of a man who has dedicated himself to his art, despite the problems facing the artist working outside the mainstream of fashionable artistic activity in the mid-twentieth century. For Gunn has not only painted for his livelihood, he has also in his own special way attempted to throw light on some of the mysteries of the Universe, on the significance of man on our planet, and on himself, by combining his technique as a painter with his knowledge of precise sciences.

This study is based on conversations and notes supplied by the artist and his family, and I am deeply grateful to Gordon Gunn and his wife, Katharine, for all the help and advice they have given. But I would particularly like to record my thanks to Richard Gunn, for his monograph on his father's cosmic paintings; and to Gordon's younger son, Nigel, whose detailed notes on the cosmic paintings I have used almost as he wrote them. I did this not out of laziness, but simply because, after much study, I found I could not improve on his understanding and analysis of his father's works.

NEIL RHIND
October, 1972

1

INTRODUCTION

THE rôle of the artist who works with brushes and paint on canvas or paper, is not an easy one. The living artist, like the living composer, is finding it increasingly difficult to reach his public; largely because there is resistance to innovation and change in these matters but also because the public generally has always been reluctant to pay an artist a fair reward for his labours.

The work of the dead, on the other hand, can be revered and stay in demand for there is no risk that further work will be so different in style and intent that theories will need to be altered. There is also less inhibition in exploiting the market, for not only is the artist no longer present to be enraged at the prices his work will fetch, but also he is no longer able to add to the number of works in currency. As the master-works disappear into public galleries and state collections the number of pictures on the open market dwindles and the value of this shrinking group moves up and up. Good investments for those who mistrust banks, diamonds or property.

The living artist may be fortunate. He may – whether endowed with exceptional talent or none – manage to appeal to the art-buying public not only through the technical quality of his painting, but also because he is able in his work to reflect the feelings and moods of the society he lives with. Even better, he may be fortunate enough to enjoy critical acclaim, appear on television, have his works purchased for public collections and be written about in the popular press. The common fate of the fashionable artist's reputation is that, after his death, there is a massive re-appraisal of his work and his reputation declines. The name will be forgotten or become regarded as an interesting tributary in the mainstream of art history.

Added to this is the fact that the art purchasing public is not large, and there is much call on its attention and purse. It is true that the British as individuals have never purchased pictures in anything like the quantity the artists would like. Yet we are collectors of reproductions: we love pictures, and although people try to tell us that it is much better to have an original painting on our walls than it is to have a print of the Mona Lisa, a Cezanne, a Breughel, or even a David Hockney, we find it safer, much more comforting, to spend our money (sometimes quite a lot of it) on a print of a known old favourite, than to risk the derision of our friends by backing the work of a living artist.

This self-doubt leads the public into a situation where it denies the artist payment even for a fair day's work, let alone for the years of training, research, and the building up of craft skill that Whistler called 'the lifetime of experience', that makes the artist's life in the United Kingdom a financially unrewarding profession.

Most young men out of art school enter teaching, graphic design, or commercial art studios, content to be paid a regular wage or salary and use their skills less for their own satisfaction than at the behest of others. This is not to say that all artists working as teachers or in the commercial world are slaves to a system. Many chose these fields because that is what they want to do, and they do it well and with success, enriching our lives and improving the design of much we buy and see.

But of the many who want to paint as a means of earning their living those that do probably enjoy one of the lowest returns for labour of any group in society – bar poets.

And of the large numbers who start their professional life with the intention of making a full-time living with their brush, only a few are successful: the exceptionally talented, the lucky, the fashionable. Most have to become weekend painters or marry wives with money. Perhaps society has dictated that the painter should not be allowed to live solely as an artist. Painting has been decreed a hobby, or leisure activity, which is the fashionable way of describing what we would all prefer to be doing if we were not having to earn our living in factories or offices.

Fortunately for us all there are some artists who can survive despite the pressures and vicissitudes of the life they choose to lead. Men and women, who, because of their skill and talent, their humanity and insight into the human condition, have been able to dedicate themselves to their art. They are mostly unimpressed by critical acclaim or derision, following the paths that they know must be followed, working sometimes with the flow of fashionable opinion and sometimes against it, but caring little either way. Of course, the artist is human, he enjoys praise and appreciation; it is a biological fact that animals

2

Opposite: *Before the Cataclysm*

dedication which the small boy took as normal. But looked at from the sidelines, and impersonally, this does not seem to have been a normal upbringing. Few of us have a father of such calibre, whatever we may think as children. Gordon Gunn was fortunate in having a bedrock of creative success on which to build.

From boyhood, Gunn has remained a strongly self-sufficient person, dodging, as he says, the influences of other people. A self-contained unit driving through life, absorbing what is necessary from the surrounding scene, but dedicated to a single purpose ahead. The pleasures of travelling are less important to him than the ultimate goal.

Thus, Gordon Gunn accepted high standards as commonplace. But because they were commonplace the targets to be achieved were that much harder, even though the young artist did not realise it at the time.

But fierce independence for an artist means a struggle against a system. The system Gunn had been born into was one of political and social inequality, artistic ignorance on the one hand and attempts to corrupt the artist's principles by exploiters and speculators on the other. It was the elements of this which drove Gordon Gunn away from his fellows to seek solitude and escape from man and his effect on the environment. Man's significance as a group (not as individuals) in Gunn's work is of no consequence. The viewer will search Gunn's total work and find only a handful of people. And those will add little to the essence of the work, they simply help one to relate man's achievement to the enormous scale of the Earth and the Universe.

Gordon Gunn was born into a world of inequality. Despite the celebrations which greeted the end of the Great War and welcome home given to the survivors of the trenches, Gunn's formative years were those of slump and depression. Thousands of Glasgow children walked the streets barefoot. The industries around the city were hard hit and when the General Strike came Richard Gunn was one of the few still in employment.

It was during this period that the boy witnessed a scene that shocked him into realising that life was not for everyone the comfortable and secure world of his own home and family; that his fellow creatures could be driven by social conditions to the cruelties of madness and despair.

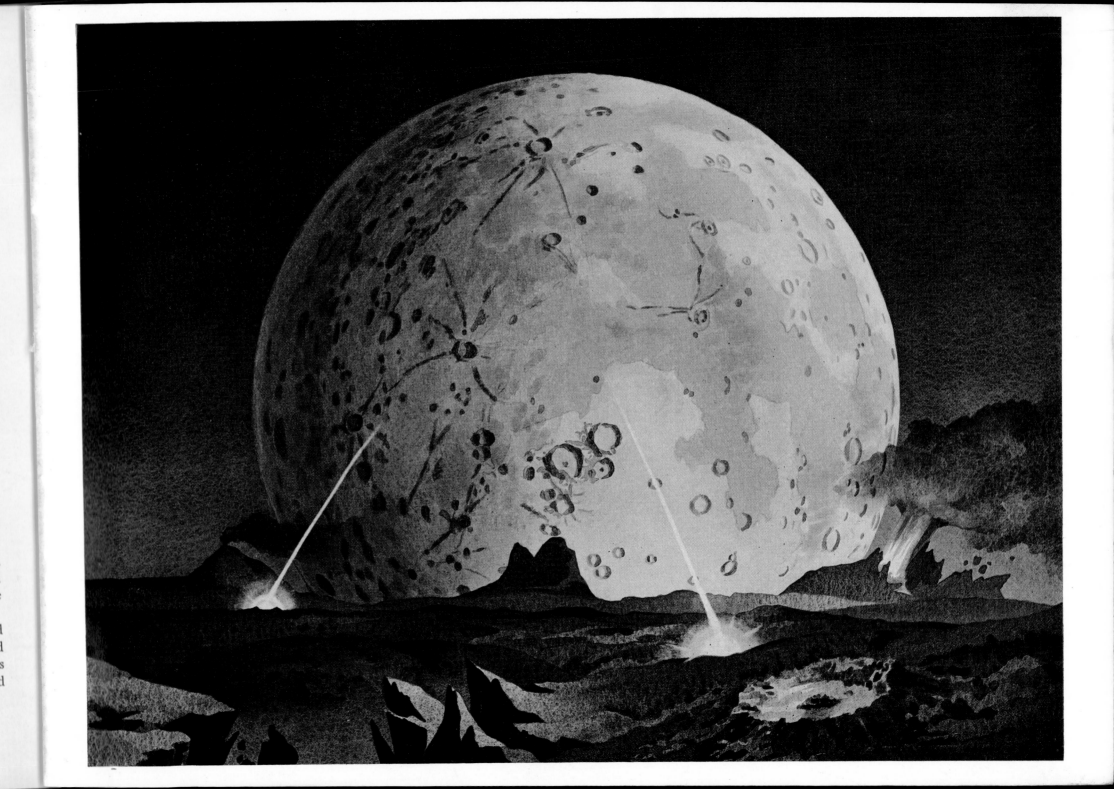

become listless and dispirited if starved of company and affection. The musician's music will have no meaning for us until it is performed; the writer writes because he wants other people to read his words; and the painter paints to communicate his ideas to others as well as himself – although many would argue this point. He paints to satisfy his own enquiries and in doing so throws light on the nature of the human mind and the workings of the Universe. But if we do not look at his work we cannot learn from it.

One painter who could almost be described as the epitome of my argument in the paragraph above is Gordon Gunn, the Scots water-colour painter who has followed an independent course since he left the Glasgow School of Art in 1939.

He is a man fiercly proud of his Norse origins, without being a slave to the superficial trappings of sentiment and public demonstration. As an accurate recorder of highland landscapes and seascapes he is almost certainly without equal at the moment, and his choice of water-colour for his work places him in the front rank of men working in a medium which has become uniquely British.

Gordon Gunn is one of the few painters of the 1970s making a living as a water-colour artist, having chosen the medium not only for its particular properties but also for its permanence. Many of the scenes he records, changing but unchanged, show us some of the last surviving wildernesses on our islands. Pressures of population, the exploitation of the earth's dwindling resources, the march of steel and concrete across virgin hills and valleys, could destroy much of the Highlands of Scotland in spite of efforts made to protect and preserve this unique environment. If, in the years to come, the landscape is desecrated there will at least be Gordon Gunn's work as a reminder of what we have lost.

But Gunn is more than a recorder of the attractive scene. He has an uncanny insight into the universal problems of creation and time, space and spacelessness, and the observer who has known his work for some years cannot help but have his private perception of the meta-physical altered or confirmed. I certainly find that Gunn's work has shown me that, without doubt, man's significance in the Universe is little more than that of a tintack. I probably knew it before but it took Gordon Gunn to confirm and consolidate my instinct.

During the blackest days of the stoppage, when the mood of the workers was at its ugliest, and transport almost non-existent, Gordon Gunn was walking down the Great Western Road when a tramcar drove by. Seemingly from nowhere an angry crowd materialised and descended upon the solitary tram, hurling bottles and stones. Eventually the vehicle stopped, and the driver, most probably a student, was dragged from it and viciously beaten. The victim was long past struggling before the mob disappeared and in the suddenly horrid silence two men crept forward and carried the lifeless form away.

Gunn has never forgotten a single detail of this episode for he had seen and realised, even at the age of 10, the dangers of what came to be called the unfair society – the danger of anarchy.

There was no anarchy or danger in his own background. Middle-class manners and a proper respect for education ensured a high standard of work at Hillhead High School, where he studied sufficiently diligently to achieve a place at the Glasgow School of Art. But, more importantly, it was at school he received his first lessons in painting from an artist other than his father. Hugh Cameron Wilson, a Glasgow painter Gunn much admired, introduced the boy to drawing with charcoal and persuaded him to take a broader look at things. Patiently and with good humour, Wilson taught Gunn about papers and different types of canvas, and much about the history of art. He ensured Gunn's success in his school examinations and this support must have helped the boy cope with the shock of his father's premature death in 1933, when Gordon was only 17 years old.

The new student enrolled at the Glasgow School of Art in 1934 with advantages denied to most freshmen: his father had studied there and many of his works were displayed in the Architectural Department; his cousin James (later Sir James Gunn, P.R.P., R.A.) had studied there, and an uncle was a governor of the College. Not unnaturally, the new student experienced feelings of awe at being in so hallowed a building even though he preferred, architecturally, the buildings he had watched his father create.

Two personalities in particular stand out from his student days: Sir William O. Hutchison, the then Principal of the College; and Gunn's teacher, Ian Fleming, R.S.A., whose job it was to teach students how to draw, how to look at things afresh and how to recognise something of their inner quality. The pupils warmed to Fleming and Gunn remembers how much he owes to this man's advice and his ability to bring a student's sketch to life by a simple flick of the chalk.

With his background it was inevitable that Gunn would be drawn towards the theory of design. He had shown little interest in portraits and the human form – other than the necessary attendance at life classes and academic productions – and preferred technical subjects.

Many of the family contacts and most of his father's friends were architects. One of them, John Watson, had taught Gunn, informally, the art of reading plans. This eventually led to the study of the theory of structures, building methods, and civil engineering to the point where the student was able to see a structure as a solid merely by studying a flat plan. This was to prove of immense value nearly thirty years later when the artist was commissioned to produce impressions of dams, bridges, buildings and motorways.

Another benefactor was Alexander Melville, who had been a close friend of Gordon's father. His sympathy and help meant a great deal at the time of Richard's death, when the family found itself in some financial difficulty, as most of their resources had been spent on long-drawn medical care. The boy's distress and confusion were comforted by Melville's perceptive and generous offer to be responsible for the fees at Art School.

He also gave the raw student his first commission; an artist's impression of an extension to a distillery building. This was not as much of a risk as it seems, for the boy had had the technique explained to him by his father, and Melville had seen enough of Gordon Gunn's attempts at the genre to know he had the talent.

Gordon worked on that commission with passionate care and gratitude and arrived promptly to deliver it, torn between pride of achievement and nervous apprehension. He found Melville's office in confusion, and the staff distraught and uncomprehending. By a tragic irony – and totally unexpectedly – Alexander Melville himself had died earlier that morning.

It is not perhaps surprising that in Gunn's mind at this time Glasgow became a city synonymous with cruelty and death.

It was during his student days that Gordon Gunn first began to

appreciate the freedom and solitude of the Highlands. His immediate ancestors came from Thurso in Caithness, and the Gunn line stretched back to the Norsemen. But it was in the Western Highlands that Gunn found himself most at home. Time and again he made his way northwards to Morar to try to free himself from cities, noise, dirt, human chaos and pain.

Astronomy was a subject that particularly excited Gunn's curiosity and from his early student days he made an extensive study of the subject, acquiring a good working knowledge of optics and the rudiments of celestial mechanics, although he assures me that he knows little or nothing of that discipline. All the same, his knowledge deepened into an understanding of many of the technicalities of astronomy, and this helped greatly towards making the painstakingly accurate renderings of the Heavens in his cosmic paintings. Such work, calling as it does for as much knowledge as there may be at the disposal of the artist, requires also insight and an eye for strange relationships, like "seeing a universe in a drop of water", or a geological age in a mountain slope.

Music was more than just a passing phase. He took the subject seriously enough to study under Dr. Cedric Thorpe Davie, learning the elements of harmony, counterpoint and orchestration over a three year period, and deepening his understanding of the music of Sibelius and Beethoven, in particular the last quartets, and hearing for the first time, the music of Bruckner.

It is not surprising that these three composers speak to Gunn as they do. The controlled muscular power of these giants, the last two pursuing their own individual line in music, aside rather than part of the mainstream of musical development, parallels Gunn's own development in art. The creation of new forms, the rendering visible of ideas which are superficially outside human experience (as with Gunn's cosmic paintings) and the Universal strength of their insight and the ability to explain some of the mysteries within, are achievements vouchsafed only to a few.

This complex mixture of interest in art, architecture, music and science, meant that Gunn was torn over which studies he should pursue. In those days a student was not buffered by a grants system and although Alexander Melville had helped considerably towards the cost of art school fees, no young man without private means could contemplate the future lightly. Unemployment was high, even for professionals the openings were few.

Teaching had some appeal although Gunn knew he lacked the vocation for this and also that it would leave little time for creative work of a purely personal nature. The life of a professional artist then was as precarious, if not more so, than it is now. But the world of the artist and the architect in those days was not dissimilar. In the Gunn family artists and architects were frequent companions having much in common. But for a young man of talent who now had a widowed mother and two younger sisters to care for, architecture was a much more promising field financially.

Thus, because of his interest in scientific and technical matters and because the family background favoured the change, Gunn apprenticed himself to an architect and enrolled at the Royal Technical College on a three year course. At the end of his first year his efforts won him a bursary which considerably eased the burden of study and support.

All the time during his student days Gunn was studying and painting everything and anything that took his fancy. His music course had given him sufficient skill and inspiration to write and play his own compositions, although any strong feelings that his directions lay along paths of music rather than the plastic arts were diluted when he discovered works, the Sibelius 4th Symphony for example, which showed that others had reached the north pole before he had half-completed the journey. Nevertheless, what music survives of these student days is not without merit and the two pianoforte sonatas have enjoyed a rediscovery in the hands of skilled amateurs to the delight of Gunn, his family and his friends.

Rarely is the student of art unaffected by the examples laid before him by his mentors and teachers. It is inevitable that during the formative years certain styles, periods, techniques and subjects will attract the artist more than others.

Nor can he finish his studies without a knowledge of the masters and come away with anything but respect and admiration for the works of Leonardo da Vinci, Michelangelo, Rembrandt, and the other giants in the history of painting and drawing. Yet to claim influence by men of

6

Opposite: *The Dying Sun*

me a *modus*
which would
hild finished

of Gunn's
hich he has
least, could

ve him the
ged terrain.
One evening
sing behind
night sky,
rawing of it
o scale, the
and Gunn
f the moon
rward, and
ling off the

ons: If the
the tides
nic to man.
t.

d with him
uch back-
h became

a place to
tinuing to

He was in
biting and
ation and
rt teacher,
he cosmic

paintings. And his output was growing.

This was a fruitful time. Seascapes and landscapes flowed out from under his brush, and artists' impressions of architectural and engineering works acted as a stimulus to his creative processes. In 1953 he shared an exhibition with an old school and college friend, George Stevenson, at McClure's Gallery in Glasgow. In 1955 he designed a new home for the Chief of the Clan Mackintosh yet was still able to find time to plan his first London exhibition at Walker's Galleries, New Bond Street, which opened in the Spring of 1957.

Meanwhile, two more cosmic paintings had emerged: *The Dying Sun,* and *The Water World.* The first of these shows an eternal sunset over Morar, the world almost dead and moving towards its final disintegration. It is, in many respects, a companion work with the first Cosmic, *Before the Cataclysm,* for in the first Gunn saw the Moon as the menacing planet, and in the second it is the Sun, even in death, controlling the destiny of our own planet.

The third cosmic, *The Water World,* showing Earth seen from a point in space 24,000 miles away, proved to be curiously prophetic. Painted in 1955 it attempted to show what the world would look like to a space traveller. No space pictures existed at that time and Gunn was unaware of the work of artists like Chesley Bonestell, in the USA, who were painting impressions of space and planets other than our own.

Yet when man did eventually travel in space and was able to send pictures back to earth, the painting Gunn had made all those years before showed much the same image – with the exception of the cloud forms which Gunn had drawn aside in order that the viewer might identify the subject more readily.

The Water World was sold to Bertram Tawse, an Aberdeen businessman, for a price which was then the highest ever paid for a water-colour work by a living artist. Tawse had known Gunn and encouraged him through the purchase of landscapes for many years.

Despite the pleasures of being an artist in Inverness, Gordon Gunn knew that if he was to achieve a more than local reputation and make a satisfactory living he would have to take a closer interest in the exploitation of his work. There was a risk of becoming known solely as an illustrator of the region and his cosmic paintings had been erroneously

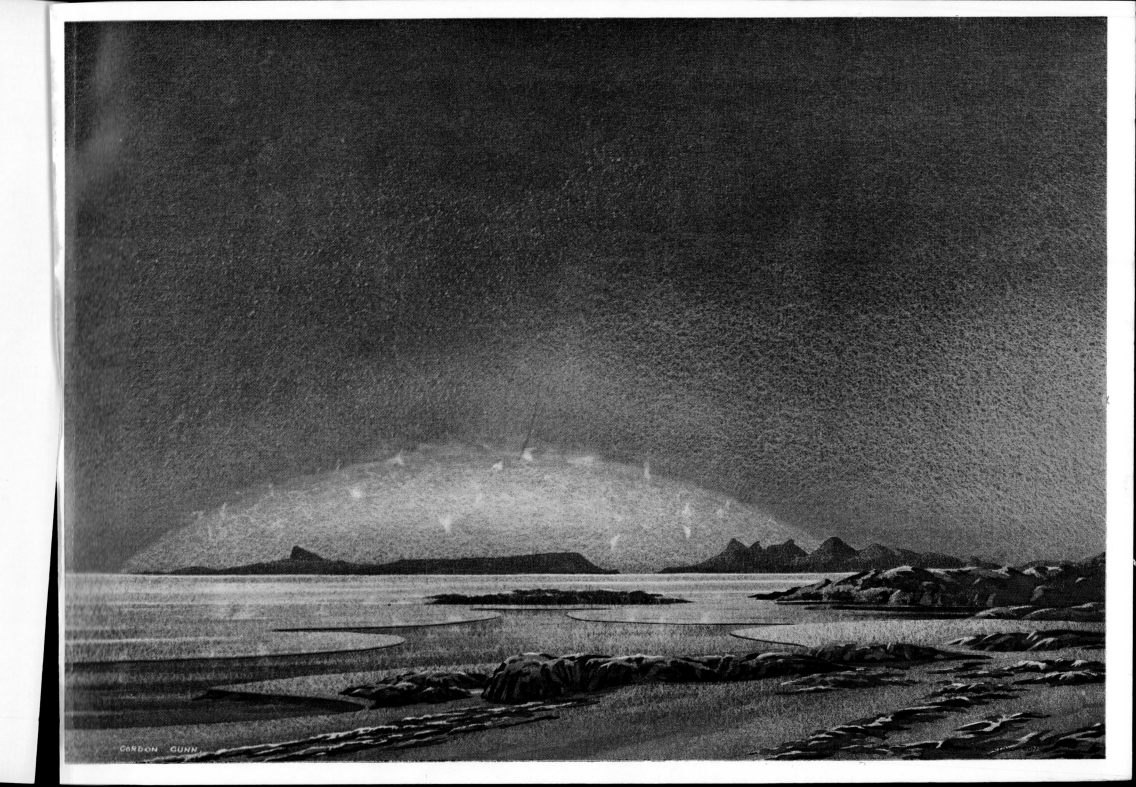

GORDON GUNN

this calibre can invite something dangerously close to derision for the living artist. But there is no doubt that study at College and personal discovery led Gunn to idolise the work of Piranesi, Tintoretto and Rembrandt, and he felt drawn, conceptually and in every other way, to Leonardo da Vinci. None of this should strike us as surprising when we look at Gunn's work since his maturity.

Two other sources of inspiration for Gunn were the works of Michelangelo and Grunewald, and it was from studying their drawings and paintings that he first properly understood how important it was to build up an idea, decide on its method of execution and make prelimi-nary sketches, long before starting the final version of the work. Proceeding in this way, little is left to accident or chance – Gunn does not despise inspiration of the moment, but he believes one of man's greatest attributes is his capacity for consequential thought.

The abstract, the tâchiste, the action painting holds no appeal for Gordon Gunn. Indeterminacy has no place in his creative processes for his skills were forged from a mastery of technique and professional-ism, by a striving after perfection through the application of knowledge, logic and the proper use of hand and eye. This is an unfashionable basis for production at the time of writing when the boundaries of artistic expressions have been stretched and the public have been bemused beyond sense into accepting the most bizarre extremes of method.

During the war, Gunn's sense of design was put to work helping in the design of camouflage for water pipes running down Ben Nevis; and later he was drafted to the Spey Development Scheme, a project involving the construction of dams, aqueducts, power stations, bridges, roads and tunnels.

It was probably the war period which confirmed him eventually in the rôle he had chosen in adolescence. But for a decade architecture and surveying activities supplied the bread and butter and gave him at the same time the opportunity to paint the area he now knew so well.

After the war he returned to his technical studies, becoming a qualified surveyor in 1949.

Thus, the period of training and discovery had come to an end and he felt able to show himself to a wider public. Gunn's work had been exhibited during his student days but in 1945 some of his paintings in

water-colou
The medi
choice in pa
the reason f
He says:
that from m
and recogni
medium's p
was stressed
Jack Coia,
lot. His eff
this medium
me as a nat
compete w
water-colou
The artis
(as possibly
as a mediu
for a living
what is poss
to be far fr
itself to the
ments of gr
to express
flat-wash p
what he w
space he s
on for eve
thick coats
as 60 or m
Gordon
example –
water-colo
He also
rather tha
because hi
presented

referred to as 'science fiction', although the passage of time had (alarmingly perhaps) proved one of them to be scientific fact.

After much thought and some anguish Gunn made the journey south in 1958 and set up a studio at Blackheath, in south-east London. Wisely, he kept his studio in Inverness and for some years commuted between the two, joining that select if eccentric band of men who commute on Britain's longest continuous rail journey, from Euston to Inverness on the Royal Highlander Express.

What surprised Gunn most about London was that little of the art he saw in commercial galleries seemed to have much bearing on what he was doing and, later, that what he was doing had even less relevance to what was seriously accepted in the name of contemporary art. No doubt, if he had just graduated from art school he might have felt it necessary to allow his style and methods to be dictated by shifting fashions and demand, but Gunn was a mature artist, painting what he felt he had to paint, in the way he knew best. He stuck to his path and has stayed on it ever since.

He began exhibiting at the Royal Society of British Artists in 1961, had his first acceptance by the Royal Academy in 1962, showed at the Royal Institute of Painters in Water-colours in 1962, and the Royal Society of Marine Artists the same year. That, coupled with membership of the United Society of Artists has ensured a showing of more than 200 works at the Federation of British Artists' Galleries, many of them going out on tour in the United Kingdom and abroad in the series entitled *Britain in Water-colour, the British Scene* and *Coasts of Britain*.

The journey to London did not lose him the friendship and patronage of the Tawse family, to whom Gunn owes an enormous debt. Not simply one of finance but because private patrons prepared to back their own judgment are today a vanishing breed. Bertram Tawse and his wife have not only bought a good number of Gunn's works for their own pleasure but have generously given examples to public collections in Aberdeen and Lerwick.

There has been an increase in the flow of work since Gunn's arrival in London, for the self-imposed exile brought him contact with the countryside of southern England and gave him fresh inspiration. The contrast of the softer landscapes of the Downs and the warmer, less stark, ports and harbours of the south coast presented a challenge to the artist used to the harshness and grandeur of the Scottish landscape. Much work of this period was shown at a highly-successful one-man show at the Federation of British Artists' Galleries in 1969, at which seven cosmic paintings dominated the exhibition. The success of this show helped much towards the financial security of the artist and his family.

Gordon Gunn continues to be fascinated by the cosmos. After the completion of his painting *The Field of Mars*, both the American and Russian Mars space probes sent back information about the planet which confirmed many of his theories. No longer could his work be looked on wholly as indulgence in scientific fantasy – much of what he had drawn and painted had been proved scientifically accurate.

He has also been much encouraged by the developing interest of his son Nigel, now studying astronomy at St. Andrews.

It is pleasant to leave the story at a happy point. In 1972 Gunn had to find a replacement for his Inverness studio, the lease having come to an end. By a fortunate chance, a small cottage came on the market at Arisaig, in the Morar district, which had always been a fruitful source of inspiration to him.

And in the same year more than 60 major works were shown at the 26th Edinburgh International Festival. Gunn was invited to exhibit at their special Edinburgh Festival exhibition by the Douglas and Foulis Gallery, sharing the wall space with Aberdonian artist John Semmence.

COSMIC PAINTING

Cosmic painting is concerned with the universe as a background to man's activities. This background is usually taken for granted but cosmic painting speculates on the way it may intrude upon man's everyday life and his environment. Sometimes the intrusion can be violent and sometimes it can be silent and minute, as in the heart of a flower.

Because much of the universe is still unknown to man, the way in which cosmic events are present in man's life is analagous to the way in which new ideas concerning the universe manifest themselves in man's consciousness. Old theories have to be disturbed in order to be advanced or replaced by new theories.

In pictorial terms, Gunn's cosmic painting conducts this speculation by dealing with those parts of the world which cannot be seen, or not seen from normal visual viewpoints. To this end it brings together events from different times and spaces so as to give rational form to significant ideas. Our normal view of the world, which in the past has often been found wanting, has forced us to develop aids beyond the scope of the senses acting on their own; the telescope, and the microscope bring us new visions; they also add stylistic elements to cosmic painting. And it is the cosmic painter's task to see things in such special relationships as to trigger off new ideas about them.

A cosmic event takes place at the point where man's understanding and his web of habitual concepts fade off into uncertainty. In other words, where his subjective world comes into contact with the objective background of the universe as a whole. The cosmic painter does not claim objective or absolute correctness for the ideas he expresses or depicts, all ideas being subjective and to some extent influenced by their human environment. He can claim that his ideas retain their value and importance when set against the ultimate background of the universe, and that like the situations he depicts, they have their source in this background rather than in human psychology.

Cosmic painting is not science fiction in artistic terms, although the motive behind it is similar to the scientist's motive. For the cosmic artist, activated by a spirit of enquiry, hopes for a new vision with which to promote new ideas about man's place in the Universe and his possible future. In the end, he aims to provide all of us with a view of the Universe which will help us see our own affairs and their cosmic background, in a broader and more detached perspective than before.

Although Gordon Gunn was probably the first to distinguish art of this special type and pursue it deliberately, there are many examples of such works by other painters, from the past, as well as working now. There are good precedents for most of the stylistic elements of perspective, composition and form, which Gunn adopted. The work of Turner and John Martin (Gunn had not seen Martin's work in the original until completing his own fifth cosmic painting) are notable here, as is the work of two artists: from the United States, Chesley Bonestell (who was commissioned to paint artist's impressions by N.A.S.A.); and Ludek Pešek.

But Gunn's personal and original contribution can best be estimated and understood by studying the pictures themselves. And it is essential to take account of the other fields of human creativity from which his paintings draw their inspiration. As important as the purely artistic influences that the viewer can trace is the wealth of scientific knowledge which has been used to good purpose by Gunn's receptive and imaginative mind.

Yet Gunn began this process independently and without conscious knowledge of any similar work being done by others. Thus the purpose behind the cosmic paintings owes little to the artistic tradition with which he was familiar. While his debt to science is more obvious, it is felt that this will be more fully repaid when those who are involved in a close and quantitative study of things pause to take a reciprocal interest in art. In recent years, which have seen such spectacular advances, particularly in space science, cosmic painting shows little sign of becoming obsolete but rather of gaining impetus and breadth.

It is noteworthy that suggestions are even being made for artists to be included in space flight crews.

But there is another aspect of Gordon Gunn's cosmic painting which, to those who know them well, is more important than the technical and scientific rationale. However remote the source of inspiration, the finished work always reveals the same love of landscape, the eye for distances and light, a response to mood and colour, the compelling

Opposite: *The Water World*

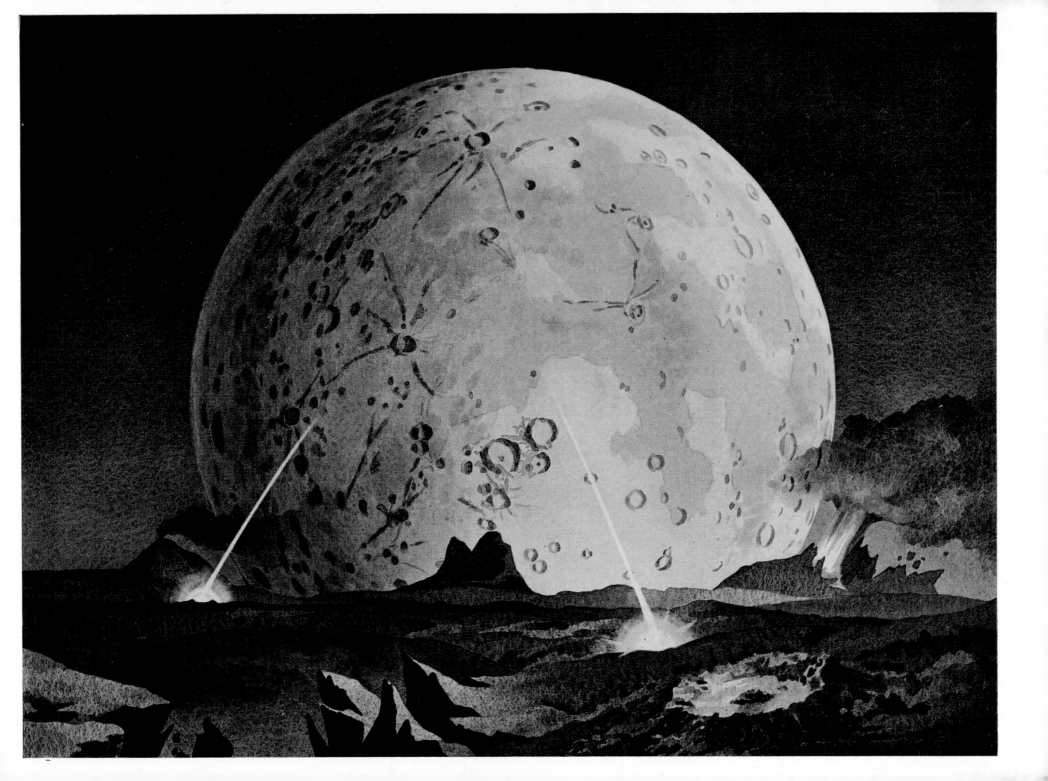

become listless and dispirited if starved of company and affection. The musician's music will have no meaning for us until it is performed; the writer writes because he wants other people to read his words; and the painter paints to communicate his ideas to others as well as himself – although many would argue this point. He paints to satisfy his own enquiries and in doing so throws light on the nature of the human mind and the workings of the Universe. But if we do not look at his work we cannot learn from it.

One painter who could almost be described as the epitome of my argument in the paragraph above is Gordon Gunn, the Scots water-colour painter who has followed an independent course since he left the Glasgow School of Art in 1939.

He is a man fiercly proud of his Norse origins, without being a slave to the superficial trappings of sentiment and public demonstration. As an accurate recorder of highland landscapes and seascapes he is almost certainly without equal at the moment, and his choice of water-colour for his work places him in the front rank of men working in a medium which has become uniquely British.

Gordon Gunn is one of the few painters of the 1970s making a living as a water-colour artist, having chosen the medium not only for its particular properties but also for its permanence. Many of the scenes he records, changing but unchanged, show us some of the last surviving wildernesses on our islands. Pressures of population, the exploitation of the earth's dwindling resources, the march of steel and concrete across virgin hills and valleys, could destroy much of the Highlands of Scotland in spite of efforts made to protect and preserve this unique environment. If, in the years to come, the landscape is desecrated there will at least be Gordon Gunn's work as a reminder of what we have lost.

But Gunn is more than a recorder of the attractive scene. He has an uncanny insight into the universal problems of creation and time, space and spacelessness, and the observer who has known his work for some years cannot help but have his private perception of the meta-physical altered or confirmed. I certainly find that Gunn's work has shown me that, without doubt, man's significance in the Universe is little more than that of a tintack. I probably knew it before but it took Gordon Gunn to confirm and consolidate my instinct.

In this book I have not really attempted to put forward views and theories on his art, or about the man, for he is still living, active and in his prime. I am not a critic, nor an art historian and I have left matters relevant to them out of the scheme. This is a book about an artist whose work I find inspiriting and enriching and whose work will now, I hope, find a wider public through the medium of print.

This book is a biography of the man, and describes his pictures. The question of interpretation is left to the reader.

Gordon Gunn's earliest memories of art go back to his infancy when he was allowed to watch his father at work. Father was architect Richard Gunn, trained at the Glasgow School of Art (from 1899 to 1904), winner of the Tite Prize and a Rome Scholar. He married Margaret Henstock in 1912 and Gordon, born in 1916, was the first of three children.

Gunn recounts how he watched, fascinated by his father's ability to breathe life into a few lines on a piece of paper. On Richard Gunn's drawing-board houses, banks, shops, factories and even a castle, all took on a living form. When his father added human figures, cabs and even a motor car to give a scale reference to his impressions of new buildings it had an electric effect on his son.

Not only did Gordon Gunn benefit by this introduction to the world of art at an early age, but the boy was frequently taken to Scottish art galleries and museums so that by the time he was eleven, one of life's joys had become his independent visiting of the Glasgow Art Gallery in Kelvingrove Park. But looking back from his present situation possibly the most important influence in his eventual career came as the result of instruction.

His father not only encouraged the boy to paint and draw but showed him how to mix colours and apply washes, and instructed him in the art of composition generally. The influence of an established professional not only in technique and choice of subjects, but in the selection of materials, brushes, paper, the elements of setting up resources in order to create and develop within the chosen medium, was imprinted on Gordon Gunn's mind at a receptive age.

Richard Gunn – who could draw and paint with both hands at the same time – encouraged the boy to draw everything and anything that took his interest, criticising and correcting where the young hand had gone wrong. It is not surprising, therefore, that Gordon, on a visit to the Glasgow Art Gallery to draw a Greek vase, had his attention excited by a competition for young artists. Much to his delight his own entry won a silver medal – the first taste of success.

His father's influence cannot be over-emphasised. Although by Gordon Gunn's own account an independent man made sombre by ill-health, he created an atmosphere of skill, professionalism and dedication which the small boy took as normal. But looked at from the sidelines, and impersonally, this does not seem to have been a normal upbringing. Few of us have a father of such calibre, whatever we may think as children. Gordon Gunn was fortunate in having a bedrock of creative success on which to build.

From boyhood, Gunn has remained a strongly self-sufficient person, dodging, as he says, the influences of other people. A self-contained unit driving through life, absorbing what is necessary from the surrounding scene, but dedicated to a single purpose ahead. The pleasures of travelling are less important to him than the ultimate goal.

Thus, Gordon Gunn accepted high standards as commonplace. But because they were commonplace the targets to be achieved were that much harder, even though the young artist did not realise it at the time.

But fierce independence for an artist means a struggle against a system. The system Gunn had been born into was one of political and social inequality, artistic ignorance on the one hand and attempts to corrupt the artist's principles by exploiters and speculators on the other. It was the elements of this which drove Gordon Gunn away from his fellows to seek solitude and escape from man and his effect on the environment. Man's significance as a group (not as individuals) in Gunn's work is of no consequence. The viewer will search Gunn's total work and find only a handful of people. And those will add little to the essence of the work, they simply help one to relate man's achievement to the enormous scale of the Earth and the Universe.

Gordon Gunn was born into a world of inequality. Despite the celebrations which greeted the end of the Great War and welcome home given to the survivors of the trenches, Gunn's formative years were those of slump and depression. Thousands of Glasgow children walked the streets barefoot. The industries around the city were hard hit and when the General Strike came Richard Gunn was one of the few still in employment.

It was during this period that the boy witnessed a scene that shocked him into realising that life was not for everyone the comfortable and secure world of his own home and family; that his fellow creatures could be driven by social conditions to the cruelties of madness and despair.

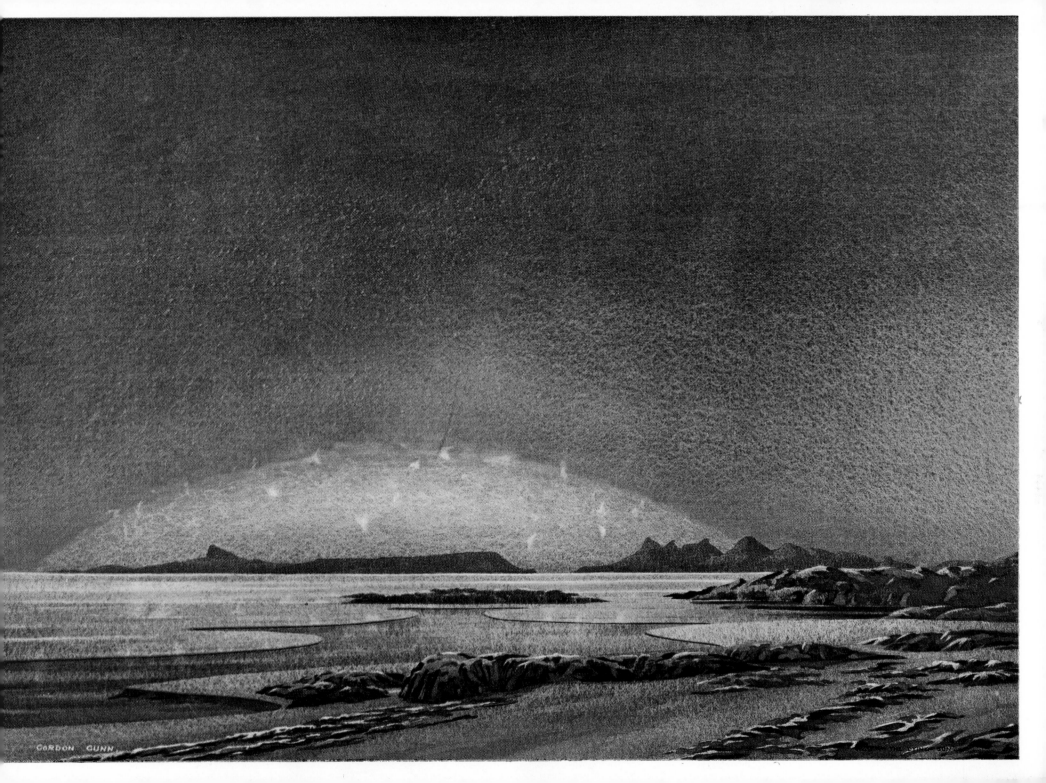

GORDON GUNN

this calibre can invite something dangerously close to derision for the living artist. But there is no doubt that study at College and personal discovery led Gunn to idolise the work of Piranesi, Tintoretto and Rembrandt, and he felt drawn, conceptually and in every other way, to Leonardo da Vinci. None of this should strike us as surprising when we look at Gunn's work since his maturity.

Two other sources of inspiration for Gunn were the works of Michelangelo and Grunewald, and it was from studying their drawings and paintings that he first properly understood how important it was to build up an idea, decide on its method of execution and make preliminary sketches, long before starting the final version of the work. Proceeding in this way, little is left to accident or chance – Gunn does not despise inspiration of the moment, but he believes one of man's greatest attributes is his capacity for consequential thought.

The abstract, the tâchiste, the action painting holds no appeal for Gordon Gunn. Indeterminacy has no place in his creative processes for his skills were forged from a mastery of technique and professionalism, by a striving after perfection through the application of knowledge, logic and the proper use of hand and eye. This is an unfashionable basis for production at the time of writing when the boundaries of artistic expressions have been stretched and the public have been bemused beyond sense into accepting the most bizarre extremes of method.

During the war, Gunn's sense of design was put to work helping in the design of camouflage for water pipes running down Ben Nevis; and later he was drafted to the Spey Development Scheme, a project involving the construction of dams, aqueducts, power stations, bridges, roads and tunnels.

It was probably the war period which confirmed him eventually in the rôle he had chosen in adolescence. But for a decade architecture and surveying activities supplied the bread and butter and gave him at the same time the opportunity to paint the area he now knew so well.

After the war he returned to his technical studies, becoming a qualified surveyor in 1949.

Thus, the period of training and discovery had come to an end and he felt able to show himself to a wider public. Gunn's work had been exhibited during his student days but in 1945 some of his paintings in water-colour were hung in the Royal Glasgow Institute of Fine Arts.

The medium was important, for Gordon Gunn made a conscious choice in painting in water-colour and it would be well here to explain the reason for his choice.

He says: "As to why I prefer to paint in water-colour I can only say that from my earliest days I had seen water-colours around the house and recognized their great effect. I had grown to realise some of the medium's potential with my own hands. Of course, painting in oil was stressed at the art school but there was an excellent water-colourist, Jack Coia, at Glasgow when I was there, whose technique I admired a lot. His efforts on my behalf got me going, and the urge to paint in this medium came spontaneously. Rendering in water-colour came to me as a natural thing to do, and as I felt no particular inclination to compete with other painters in oil I developed my own way with water-colour".

The artist in his choice demonstrated his individuality – for then (as possibly now in some minds) it was fashionable to treat water-colour as a medium of secondary importance. It was held that as a medium for a living artist it could say nothing significant. But in Gunn's hands, what is possibly the most difficult painting medium to control is shown to be far from unimportant or secondary. Its scope is wide, it lends itself to the immediate impressionist works no less well than to statements of grand and well thought-out designs. Gunn uses the medium to express many moods, to portray atmospheric effects, principally as flat-wash paintings, as he finds this to be the best means to express what he wants. For example, when he paints pictures showing outer space he sees the background as a screen of translucent colour going on for ever and ever. The effect is achieved not by applying a few thick coats of a dark pigment but by numerous washes, often as many as 60 or more, until the result is a curious transparent dark.

Gordon Gunn has used other media – charcoal and Indian ink for example – but it is as a water-colourist that he started his career and as a water-colourist he has achieved his major successes so far.

He also found it necessary to work on sketches for many of his works rather than attempt to paint directly as he saw a subject, mainly because his speciality – the landscapes and seascapes of the Highlands – presented themselves at moments when the weather forbad anything

but the shortest moments in the open. Sketching became a *modus operandi* and Gunn took every opportunity to sketch scenes which would serve later, often years later, as the bedrock on which to build finished works.

It was this working method that led towards the first of Gunn's cosmic paintings – the series of large scale works for which he has become best known and which, in one viewer's opinion at least, could be called his symphonies.

In 1946 visits to Lochinver in Western Sutherland gave him the opportunity to study a number of landscapes in this rugged terrain. Fascinated, in the following year he made another visit. One evening after sunset he was startled by the brightness of the Moon, rising behind the mountain Suilven. The dead planet, as it rose into the night sky, looked particularly huge and menacing and Gunn added a drawing of it to a sketch he had made of the scene some weeks before. To scale, the planet looked smaller on the sketch than it had in the sky and Gunn fell to wondering what a dramatic effect could be achieved if the moon were painted huge, filling the whole sky. His mind raced forward, and I have heard him recount how he thought he saw rocks falling off the Moon and streaking back to earth.

After he collected his senses he answered his own questions: If the moon were bigger it would be nearer. If it were nearer the tides would be higher and such a state of affairs would be cataclysmic to man. It would alter his way of life, and in fact it might even end it.

This germ of an idea, which he later called cosmic, stayed with him and over the next five years Gunn elaborated it and did much background study. In 1952 he finally started a painting which became Cosmic painting No. 1: *Before the Cataclysm*.

At the end of the war Gordon Gunn adopted Inverness as a place to work and live, and opened a studio there, although continuing to exhibit at the Royal Glasgow Institute of Fine Arts.

In Inverness, Gunn found some degree of contentment. He was in the heart of the Highlands, had his own studio for exhibiting and selling and the company of artists and friends gave stimulation and encouragement. Among others he met James Cameron, an art teacher, who later interviewed him for a BBC programme about the cosmic

paintings. And his output was growing.

This was a fruitful time. Seascapes and landscapes flowed out from under his brush, and artists' impressions of architectural and engineering works acted as a stimulus to his creative processes. In 1953 he shared an exhibition with an old school and college friend, George Stevenson, at McClure's Gallery in Glasgow. In 1955 he designed a new home for the Chief of the Clan Mackintosh yet was still able to find time to plan his first London exhibition at Walker's Galleries, New Bond Street, which opened in the Spring of 1957.

Meanwhile, two more cosmic paintings had emerged: *The Dying Sun*, and *The Water World*. The first of these shows an eternal sunset over Morar, the world almost dead and moving towards its final disintegration. It is, in many respects, a companion work with the first Cosmic, *Before the Cataclysm*, for in the first Gunn saw the Moon as the menacing planet, and in the second it is the Sun, even in death, controlling the destiny of our own planet.

The third cosmic, *The Water World*, showing Earth seen from a point in space 24,000 miles away, proved to be curiously prophetic. Painted in 1955 it attempted to show what the world would look like to a space traveller. No space pictures existed at that time and Gunn was unaware of the work of artists like Chesley Bonestell, in the USA, who were painting impressions of space and planets other than our own.

Yet when man did eventually travel in space and was able to send pictures back to earth, the painting Gunn had made all those years before showed much the same image – with the exception of the cloud forms which Gunn had drawn aside in order that the viewer might identify the subject more readily.

The Water World was sold to Bertram Tawse, an Aberdeen businessman, for a price which was then the highest ever paid for a water-colour work by a living artist. Tawse had known Gunn and encouraged him through the purchase of landscapes for many years.

Despite the pleasures of being an artist in Inverness, Gordon Gunn knew that if he was to achieve a more than local reputation and make a satisfactory living he would have to take a closer interest in the exploitation of his work. There was a risk of becoming known solely as an illustrator of the region and his cosmic paintings had been erroneously

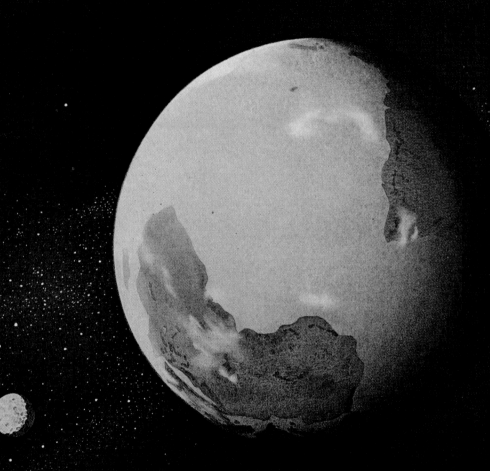

GORDON H. GUNN.

sense of place, that speaks to the viewer from all Gunn's terrestrial scenes.

After all, cosmic painting is concerned with the landscape in the very broadest sense, for the landscape of the cosmos extends over the horizon of our experience far into the past and future, from the infinite to the infinitesimal.

So it is fitting that for Gordon Gunn, cosmic painting should have had its origins in the landscape of the Scottish Highlands, when in the autumn of 1947 he stopped at a lonely road to watch the full moon rise over the mountains of western Sutherland.

THE PAINTINGS

In a world of perfect understanding a painting or work of art should be sufficient in itself, no explanation of its superficial or underlying motives need be attached. But painting is not an art from which one can express precise philosophical ideas, they belong more to the realm of words, so its strength is found generally in its power to suggest and evoke mental associations.

Cosmic painting is a mixture of memories and emotions with rational philosophical and scientific information. It could be said that the successful union of these elements is the fulcrum of Gordon Gunn's achievement and his works call for a similar breadth of approach from those who want to appreciate them fully.

The essence of the paintings is that they deal with those aspects of the Universe where man's understanding fades off into uncertainty and anyone who regards them as surrealist fantasies or simple illustrations of scientific theory will have missed the all-important resonance between the two.

The aim of the following commentaries is to highlight certain features of the works which may be less obvious in reduced reproductions than in the originals.

Before the Cataclysm. Water-colour, 27″ × 20″, painted 1953.

There are few objects more familiar to all the people of this planet than the moon. But this apparently placid and soundless orb may yet take us by surprise – there is no immutable guarantee that it will indefinitely maintain its present distance from Earth. One possible supposition is that tidal friction might cause the two bodies to draw closer together, until only six thousand miles separate them. At that point the Moon would break up under the gravitational strains imposed on it by the larger Earth. Our familiar home would then in turn suffer a three-fold cataclysm – the sudden release of gravitational stresses would initiate world-wide earthquakes and volcanic eruptions. All the waters of the sea formerly heaped up in the equatorial belt would rush in tidal waves towards the poles and, finally, fragments of the Moon would shower on to the Earth as meteorites.

This painting shows the moment immediately before the culmination of these terrible events; the sky is cloudless, the form of Earth still familiar, but ominous signs of what is about to happen are visible all round. Although partly destroyed, the scene is still recognisable from the three peaks of Canisp, Suilven, and Cul Mor, as the north-west highlands of Sutherland. But the Moon, now visible as a great spherical mountain in space, dwarfs the features of the earthly landscape. Life, as we know it, has vanished. The hospitable environment of the Earth's surface in which fragile man flourished has been destroyed. What the painter is emphasising is our comparative ignorance of the influences at work within and without the solar system, our total dependence on the continued stability and harmony of the heavenly bodies, and the possibility that something unexpected may intrude and bring this cataclysm upon us sooner than we think.

The Dying Sun. Water-colour, 33″ × 23″, painted March/April, 1954.

"So I travelled, stopping ever and again, in great strides of a thousand years or more, drawn on by the mystery of the earth's fate, watching with a strange fascination the sun grow larger and duller in the westward sky, and the life of the old earth ebb away. At last, more than thirty million years hence, the huge red-hot dome of the sun had come to obscure nearly a tenth part of the darkling heavens."

These words by H. G. Wells aptly describe the sullen landscape we see here, for this painting depicts the time and place on Earth where the dying sun is partly showing above the horizon. Exhaustion of the hydrogen in its core has caused its outer layers to swell to many thousand times their former volume, becoming cooler and more tenuous.

It will never again rise or set, for the Earth's rotation is almost halted. There is by this time no life on our planet except perhaps some hardy lichen and bacteria clinging to the rocks, for conditions under the distended sun are uncomfortably hot and the salty oceans are just about to boil. Evaporation from the water has made the atmosphere so dense that only the long wavelength red rays from the sun can penetrate it, leaving even the daylight side of the world in almost complete darkness.

Two Hebridean islands, Eigg and Rum, provide a dramatic link with the present day. From the Scottish mainland near Morar the setting sun often throws up a display of light and colour behind these islands which may suggest, by its symmetry and magnificence, some cosmic situation such as this, where man is a stranger.

Although the phenomenon of a star evolving into a red giant is commonplace in the Universe, it can only happen once in this solar system of ours. We cannot tell whether any traces of humanity will then survive on other stars or planets, but this will certainly be the fiery end of the planet of man's youth and the beginning of the end also for the sun that nurtured life upon it.

The Water World. Water-colour, 28½″ × 22″, painted February/March, 1955, purchased by B. W. Tawse, 1957.

The Water World shows Earth, five-sixths of which is covered with water, as it would appear from a distance of twenty-four thousand miles, as a large globe isolated against the background of space. It is lit by the sun on three-quarters of its visible side, and beyond it the moon can be seen. Looking at this picture now we must be careful not to regard it as an illustration of man's achievement in exploring space, for it was conceived and painted six years before Yuri Gagarin's historic, though modest, flight just outside the atmosphere. Moreover, no traces of human activity are to be seen from as far away as twenty-four thousand miles, nor any contemporary landmarks that would even fix the epoch of this planetary portrait within the age of civilisation.

It seems reasonable to call *The Water World* a portrait; and yet its subject matter implies that it is also, in a sense, a landscape, and as such posed some interesting problems for the artist. Impressions of distance are usually created in landscape paintings by perspective in one of two forms: geometric perspective uses the fact that flat surfaces and straight lines appear to converge towards the horizon, atmospheric perspective suggests the distances of things by portraying the different depths of hazy air in front of them.

It is easy to see that neither of these devices is available to the landscape painter who chooses a vantage point in deep space, because his horizon is a circle, and the atmosphere shrinks to a thin skin enveloping the Earth. Instead of providing a frame in which the painting can be built, horizon and atmosphere are reduced to the rôle of objects appearing *inside* the composition.

In painting *The Water World*, Gordon Gunn made use of the unique translucence of water-colour, for the dark background of the picture is not absolutely black, but has a resonance peculiar to its medium, which helps to create the illusion of distance and real space. Sixty-six screens of water-colour wash were used to give the necessary translucent effect. A single thick wash of very dark colour could not have produced the same result.

The most interesting features of this picture, although rendered with great subtlety, are difficult to miss. They arise from the contrast and comparison between this objective and distant view of the world and our more familiar experience of it at close quarters.

Perhaps the most striking thing about *The Water World* is its convincing portrayal of the condition of weightlessness which prevails in interplanetary space. This is achieved entirely by the positioning of the main masses on the sheet (with south uppermost), and their chosen relation to the source of light. It is uncanny that a painting should be powerful enough to induce a genuine feeling of levitation in spite of the ever-present force of gravity that still holds the observer firmly to the ground and the picture on its hook.

The Transmutron. Water-colour, 33″ × 22″, painted December, 1959, purchased by Philip Kay Esq., 1972.

This is how the Transmutron was first seen.

The artist was moving silently along a paved way through a forest. The trees were tall and dense and the day so murky and dark (if indeed it was day) that it was only by the occasional flash of lightning that his eyes could make sense of the shadowy shapes of trunks and branches through which he passed. The foliage was dark green and brown and strange types of trees could be seen.

Eventually a clearing opened by the roadside and although long upper branches formed a continuous roof overhead a little more light had found its way through and yellow lightning was distinctly visible between the leaves.

One tree stump in particular caught the artist's attention. The sides of its column were grey and smooth and upon the top a shallow dome

of the same colour slowly opened to reveal a single expressionless blue eye. Its main body, more than thirty feet high, had something reptilian in its texture yet at the same time could look like the rough hewn walls of a monumental powerhouse.

A pair of curved antennae stood out of the ground in front and another two columnar eyes were to be seen opening their lids. It bore no recognisable traces of curiosity or alarm; nor did it inspire any emotion at all. The whole cast of its being was one of infinite detachment and calm, for this creature has mastered many secrets of the Universe.

It had the power to reorganise matter, changing visibly from the likeness of an animal or plant to the likeness of a building. It had come to digest and assimilate matter on our planet in order to understand earthly affairs. Why then did it not digest the man? Could it have noticed in him a glimmer of consciousness and reason which it was reluctant to dissolve? At any rate the Transmutron's experiment in anthropology was so delicate and swift that he felt no sensation or pain.

Even long after this experience the artist could not begin to understand this alien form of life, so much more sophisticated than himself. But the encounter impressed him with a profound sense of its importance, and such a deeply-graven memory of the creature's material shape, that he afterwards performed a much simpler experiment of his own.

He painted it.

The Heart of a Rose. Water-colour, 33″ × 22″, painted February/March, 1960, purchased by Mrs. M. Tawse, 1969.

Flowering plants developed on Earth one hundred and thirty million years ago, at the beginning of the Cretaceous period, about the same time as the first mammals. It is strange to think that during the aeons before this, not a single true flower bloomed; nor were there all the varieties of insects which now frequent them.

Flowers themselves are intriguing and beautiful botanical mechanisms wherein some of the most fascinating events in a plant's life cycle are actually exposed to view. Around the heart of a rose, as its petals open, the anthers on their forest of twining stalks are already laden with ripening pollen for dispersion in the wind or upon insects looking for nectar. Some pollen will amost certainly find its way to the central cluster of hairy stigmas to be absorbed into the ovary, where the process of seed formation will start afresh.

Were it not for the scale factor of about one hundred that removes these phenomena from our common experience, the opening of every rose bud would disclose a veritable explosion of life.

The Heart of a Rose involves us as directly as possible in a situation that can only otherwise be probed with the aid of a microscope. When brought within easy reach of our eyes, its drama becomes apparent in every line and colour of the composition. Underlying the work is the thought implicit in *The Water World* – that life is an articulation of the inanimate and unconscious Universe. The event depicted is the organic reorganisation of matter so that a new cycle of life may begin. The analogy is with the conscious activity of the artist in painting it, and indeed with the origin and development of life itself.

No World Without End. Water-colour, 33½″ × 23″, painted November/ December, 1967.

No World Without End lies in the uncertain terrain where geological history merges with legend. A meteorite has plunged through the ocean and the crust of the Earth beneath, releasing sufficient energy to cause huge volumes of trap and flaming basalt to well to the surface. The shape of the basalt island of Staffa can be seen in the quasi-molten mass rising out of the sea. After the original explosive blast, the turbulent waves have closed again over the wound and are settling down into a pattern of boiling and tossing foam. The air near the vortex is full of hot, suffocating fumes and steam, shot through with flashes of lightning and caught up in circling tornados.

Brick-red light over the horizon and a glimpse of an unusually close Moon is intended to indicate that this is a local aspect of a more widespread sequence of astronomical and geophysical disturbances. Events such as this are not enough to destroy a planet, or even to extinguish entirely its flora and fauna; they are merely the greater or lesser turning-points in its history which bring one period to an end and provide the impetus for another to begin. Plato records in his *Timaeus* that the following knowledge was passed on to Solon by an old Egyptian priest:

Opposite: *The Transmutron*

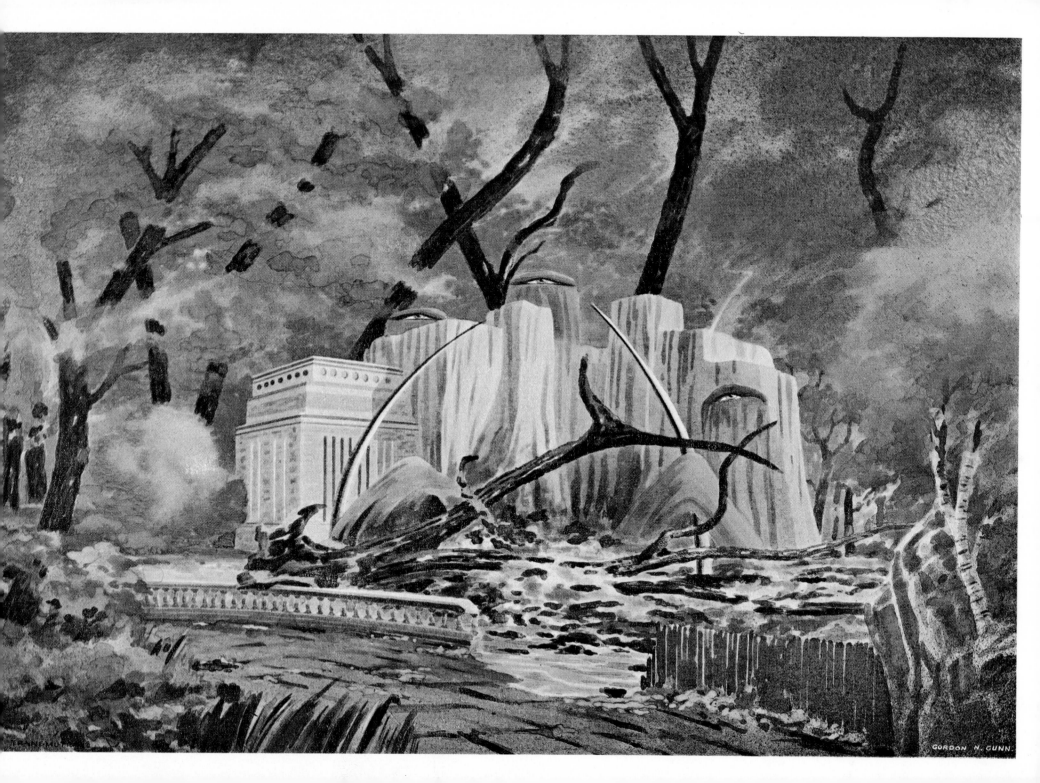

"There have been and will be many different calamities to destroy mankind, the greatest of them by fire and water, lesser ones by countless other means. Your own story of how Phaethon, child of the sun, harnessed his father's chariot, but was unable to guide it along his father's course and so burnt up things on the earth and was himself destroyed by a thunderbolt, is a mythical version of the truth that there is at long intervals a variation in the course of the heavenly bodies and a consequent widespread destruction by fire of things on the earth."

Fire and water are dynamic elements and the technical challenge of this painting was to depict them as revealed by the lurid and ever-changing lights and colours arising from their own violent conjunction. It is preceded in the artist's output by a number of large watercolour seascapes, such as *The Sea of the Hebrides,* (number 37), which it resembles in many ways. Apart altogether from its cosmic idea, it was close observation of water in motion and the experience of these slightly earlier works that made the grand marine conception of *No World Without End* possible.

The Field of Mars. Water-colour, 28½″ × 22″, painted March/April, 1969.

To anyone who looks at the night sky, the tiny size of the stars relative to space, and the way in which they are interruptions of it, is in an elementary way obvious. But this is a purely two-dimensional impression and as such does not take account of the vast distances which actually separate the stars along the line of sight. It is only the remarkable transparency of the interstellar medium that allows us to see so many of them, over a wide range of real distances, apparently superimposed and crowded together on the celestial sphere. In fact they are much further apart than they look; for the abundance of stars in our part of the Universe corresponds, not to one needle in every medium-sized haystack, but to just one grain of sand rather smaller than a full stop in the volume of Mount Everest.

How can an artist hope to portray this emptiness on a flat surface less than one metre square? The immensity of space in three dimensions can be appreciated just a little better when some solid object lies close enough for the eye to perceive its form. This will seem to stand out in the foreground while the perspective system implied by its proximity causes the stellar background to race away into the distance and the void between is thrown into relief.

The planet Mars is shown here immersed in space. Its solid surface, reflecting strong sunlight, together with the constellations of Cassiopeia, Cygnus and Lyra and the broad Milky Way, immediately claim all our attention. From a distance of about thirty thousand miles dusky patches on the martian desert are easily discernible, as is the blazing white frost cap at the south pole. Its two small moons, Phobos and Deimos, can be seen on the left side of the picture, somewhat brighter than the stars.

After a time, however, the huge blank volume of space on every side asserts its presence, and Mars becomes nothing more than one isolated interruption in its midst. This is the 'field' of Mars, and while it is to be 'felt' rather than seen, it is nonetheless the real subject of this painting. Light travelling across it to our eyes, and the forces of gravity governing Phobos and Deimos, are reminders that this field, though invisible as rushing air, is full of energy and influence.

Hyperion's Way. Water-colour, 33½″ × 23″, painted 1971.

The great planet Saturn moves around the Sun in an orbit nearly ten times as large as the Earth's, and at this distance the Sun's light has only about one hundredth of the intensity that we receive. In spite of this the yellowish globe and icy white rings are bright against the inky background of space.

Saturn has perhaps the finest family of satellites of all the solar planets. Titan, the largest, is in the foreground of this picture, its frozen surface and thin atmosphere making it look rather like a miniature *Water World* (Cosmic painting No. 3). Tethys, Dione and Rhea are visible too, pursuing their near-circular paths outside the sharp perimeter of the rings.

The scene is peaceful except for a silent flash of light in the distance as the eighth moon, Hyperion, is torn from its orbit on the far side of Saturn, seeming to explode catastrophically into empty space – but no,

this part of space is not quite empty. Following the plunging trajectory we can discern an enormous dark body. It obscures the stars beyond it, bending and splitting their light so that they appear as elongated streaks of colour splayed radially outward from its uncertain edge. Dusky swathes like misty streaks clear to reveal a hole made only of space itself, a 'Way' or passage piercing the familiar frame of three dimensions.

Normally, space and time flow so smoothly that we give them no thought, but here they have been concentrated into a powerful and disruptive knot whose effects are both tangible and spectacular. A reddened image of Saturn is held inside it. Is this some kind of reflection or could it be a pre-echo of the impending fate of Saturn? And what will become of Hyperion, already passing the threshold of the Way?

Just as Hyperion was thought once to have been god of the Sun before being displaced by Helios, the material now composing the moon named after him was part of a bright star, long ago destroyed, and has since darkened into a comparatively obscure place in the retinue of the planet called after time. Perhaps this Way, with its powerful field and a geometry alien to us is the other half of a cycle, and through it the atoms of Hyperion will eventually emerge again somewhere else, contributing to a new generation of suns. The painting *Hyperion's Way* is, like its predecessor, intended to be a speculation on the relations between matter and space-time.

Use of the opposite colours red and green, and of opposing slopes (in this instance the axis of Saturn and the implied axis of the Way) generates a feeling of mystery and unease in an otherwise calm composition. These features are shared by *The Transmutron*, which resembles it also in the sheer strangeness of its subject. It is impossible in either case to guess what may be about to happen, but the darker complexion of this work and the absence of those benign, intelligent eyes contribute to the greater sense of danger here.

This is certainly appropriate to a picture of an object evincing a strange permutation of physical law, capable of playing havoc among stars and planets. Such events do not belong on our side of the un-bounded horizons of Creation as we know it. If modern understanding of astronomy has allayed the mariner's fears about sailing over the World's edge, it has also inspired an even more terrible suggestion: that our whole solar system could one day be carried with Saturn and Hyperion over an 'edge' of the Universe.

16

INDEX OF BLACK AND WHITE ILLUSTRATIONS

cannot tell, the painter knows that the loch here is at its deepest (1,200 feet), and the mountains opposite are about 3,000 feet high, their peaks shrouded in mist. The pinnacle of future achievement, the depths of despair – perhaps?

12 *Wills Rock, Porthcothan Bay, Cornwall.* Water-colour, 16″ × 12″, painted 1959, exhibited Royal Society of Marine Artists, 1965.

Here we have only the rocks on which we stand, and we are left with the sound, but not the sight, of a gull to guide us.

13 *Queen Bess Rock, Bedruthen Steps, Cornwall.* Water-colour, 16″ × 12″, painted 1959, exhibited F.B.A. Galleries, 1962.

14 *Sunset over Dornoch.* Water-colour, 15″ × 10″, painted 1959, exhibited at the F.B.A. Galleries, 1961.

Painted at the same time as the 4th and 5th Cosmic paintings, *(The Transmutron* and *Heart of a Rose),* this small painting comments less on the glorious spectrum of the sunset than on the inevitable passage of time.

15 *Incoming Tide, Morar.* Water-colour, 15″ × 10″, painted 1961, exhibited R.S.M.A., 1962.

16 *Reeds and Reflections, Rollesby Broad, Norfolk.* Charcoal, 22″ × 16″, drawn 1961, exhibited by the United Society of Artists, 1963, bought by Bertram W. Tawse, 1969.

This charcoal was inspired during a visit to the Norfolk Broads in 1960. The artist had been sleeping in the bottom of a boat and this was the view he saw when he awoke. The late Ion Munro, art critic of the *Glasgow Herald,* described the work as: 'Rhythm of yielding-unyielding strength — a lesson in the diplomacy of nature'.

17 *On Patching Hill, Sussex.* Charcoal, 17″ × 22″, drawn 1961, exhibited R.B.A. 1962, bought by Bertram W. Tawse, 1969.

In the same *genre* as No. 27 (below) this charcoal has a similar spontaneity and apparent casualness, yet such a result was achieved only by great skill and much practice.

18 *Winter Study, West Heath, Kent.* Charcoal, 16″ × 22″, drawn 1963, exhibited United Society of Artists, 1964.

The artist was not attracted to snow scenes, having nearly lost his life in 1945 in a Grampian snowstorm, but the effect of a light fall on the black twisted oak reminded Gunn of grossly-shaped astragals in a stained glass window from which the glass has been removed. If ever a subject dictated the medium this, surely, was one.

19 *Torr Achilty Dam, Ross-shire.* Water-colour, 28″ × 18″, painted 1962. Commissioned by William Tawse Ltd., contractors, Aberdeen.

In this commission the artist was encouraged not to produce an 'artist's impression', but to show the dam, built for the North of Scotland Hydro-Electric Board, in its natural setting, with the approach roads and tail race. Once more, it was the power of civil engineering to change the course of nature that remained uppermost in Gunn's mind for although some trees and the natural growth had been preserved, and the new loch filled with trout, the landscape had been basically altered.

20 *Orkney and Pentland Firth from Thurso.* Water-colour, 28″ × 19″, painted 1965, exhibited Royal Academy 1966; F.B.A. Galleries 1968; bought by Bertram W. Tawse, 1969 and presented by him to Aberdeen Art Gallery 1971.

A precious moment of peace on the treacherous Pentland Firth. Caithness was the home of the artist's ancestors and he has visited and painted seascapes and landscapes in the county many times.

Opposite: *The Heart of a Rose*

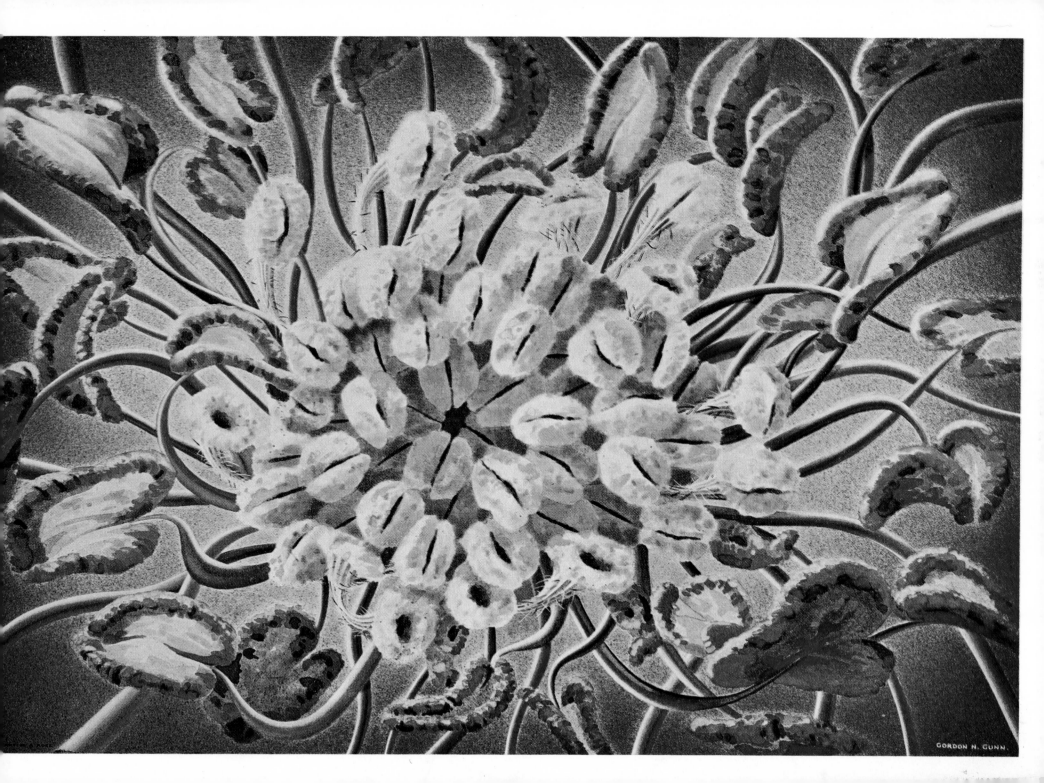

GORDON N. GUNN

21 *Corries Point, Loch Ness.* Water-colour, 28″ × 18″, painted 1963, exhibited F.B.A. Galleries, 1964.

Corrie was a follower of the Young Pretender, Prince Charles, and disposed of ten of Cumberland's soldiers near Fort Augustus. It was the scene rather than the subject which attracted the artist during a survey of the area for artist's impressions for the Hydro-Electric Board.

22 *Robots at Bay, Bowaters, Kent.* Charcoal, 22″ × 15″, drawn 1963, exhibited Industrial Artists' Group, Guildhall, 1963; tour of municipal galleries 1964; reproduced in *Bowater World News.*

A highly-finished charcoal drawing which required great care in its treatment.

23 *Gravesend Canal Basin, Kent,* Indian ink and wash, 24″ × 18″, drawn 1962, exhibited Guildhall 1964; tour of provincial galleries 1964/5; R.S.M.A. Earl's Court 1965; F.B.A. Galleries 1970.

A busy corner of Gravesend – a mecca for marine artists who wish to study small boats in a situation of captivity.

24 *Glascarnoch Dam, Ross-shire.* Water-colour, 28″ × 18″, painted 1961, bought by Messrs. Reed & Mallik, 1962.

Superficially an artist's impression of a dam, drawn as an industrial commission, but as in all Gunn's work he makes the viewer aware of more far-reaching elements of the subject. In this case, the power of man to control the forces in the water behind the dam by means of civil engineering techniques. For many years Gunn had known the limitations of life with oil lamps and peat fires – the electricity produced as a result of this dam had a special significance for him, as well as for other Highlanders.

25 *Mallaig Harbour, Inverness-shire.* Indian ink drawing, 24″ × 16″, drawn 1961, exhibited R.B.A. 1961; Hamburg, Munich, S.M.A. 1962; Brighton 1963; Industrial Art Group 1967, bought by Bertram W. Tawse, 1969.

The original sketches were made in 1954, but this busy harbour scene was not completed until 1961 and shows Gunn at his best in a rôle not usually natural to him – as a reporter of human activity.

26 *Mousehole, Cornwall.* Charcoal, 22″ × 15″, drawn in 1962, exhibited R.B.A. 1965; R.S.M.A. 1966, bought by J. M. Kretschmer Esq., 1969.

One of a harbour series in highly-finished charcoal on board. Gunn was particularly attracted by the different wall textures below the houses round the harbour, and their reflections.

27 *Study of Trees, near Patching, Sussex.* Charcoal, 25″ × 20″, drawn 1961, exhibited at United Society of Artists exhibition 1967, bought by Bertram W. Tawse, 1969.

28 *Droma, Ross-shire.* Water-colour, 28″ × 19″, painted 1963, exhibited F.B.A. Galleries in 1963, bought by Messrs. William Tawse Ltd., 1966.

29 *On Ramsgate Slipways, Kent.* Charcoal, 17″ × 22″, drawn 1963, exhibited R.B.A. 1964; R.S.M.A. Earl's Court 1966; tour of Municipal Art Galleries 1966.

Gunn says of this work: 'About this time I had many marine works on hand, and this scene reminded me of events twenty years before in Inverness . . . I was there attracted by the heaps of contractor's plant and materials, much of which looks rather untidy to the casual observer but which is, in fact, organised chaos'.

30 *Eynsford, Kent.* Charcoal, 18″ × 24″, drawn 1961, exhibited R.A. 1962; municipal galleries 1962/3; F.B.A. Galleries 1965.

This highly-finished charcoal drawing gave the artist much pleasure, particularly as he was able to introduce many details without losing the particular properties of the medium. It was finished on Christmas Eve 1961, the artist wearing gloves to protect his hands from the biting wind.

31 *Constantine Bay, Cornwall.* Water-colour, 24″ × 16″, painted 1962, F.B.A. Galleries 1962; exhibited R.S.M.A., Earl's Court 1963; Inverness 1963; Bermuda 1964; RI 1964.

The sea batters the Cornish coast, eating away even the hardest rock, slowly changing the mapline as the centuries pass.

32 *Thurlestone Bay, Devon.* Water-colour, 19″ × 15″, painted 1968, exhibited R.B.A. 1968, bought by Bertram W. Tawse, 1969.

33 *River Thames at Chelsea.* Water-colour, 15″ × 10″, painted 1960, exhibited R.I. 1963; F.B.A. Galleries 1965, owned by Katharine Gunn.

Gunn's first important work with a London subject, the murky polluted Thames, the atmosphere smokey and sulphur-laden is in direct contrast to his previous work which depicted the purity of the Highlands, clean air, unspoiled countryside and water unfouled by sewage and refuse.

34 *The Devil's Dyke, Sussex.* Water-colour, 28″ × 19″, painted 1964, exhibited F.B.A. Galleries; Brighton Art Gallery 1966, bought by Bertram W. Tawse, 1969.

This was painted from the South Downs. The village of Poynings can be seen in the left foreground and the countryside stretches for miles into the distance. The work was based on sketches of the area drawn in 1963, some of which were finished in 1964 and 1965. The artist says that he wanted to record something of the southerner's effort to preserve his environment, where the villages were not separated by mountains as in his native Scotland but only by fields and hedges.

35 *Richborough Generating Station, Thanet.* Water-colour, 28″ × 19″, painted 1964, exhibited F.B.A. Galleries 1967; Industrial Artists Group, Guildhall, 1964; tour of provincial galleries 1965.

Having spent some little time in Broadstairs Gunn became quite attached to the building work of the Generating Station and resolved to record the event simply for his own pleasure.

36 *The Cotswolds, Broadway.* Water-colour, 28″ × 19″, painted 1965, exhibited F.B.A. Galleries 1965, bought by Bertram W. Tawse, 1969.

Here Gunn has successfully captured the strange evening light when even the sun seems to operate like an electric lamp, shining on the honey-coloured stone houses with the dark grey clouds behind them.

37 *The Sea of the Hebrides.* Water-colour, 28″ × 19″, painted 1964, exhibited R.S.M.A., Guildhall, 1964; F.B.A. Galleries 1967.

Gunn had done many drafts for marine paintings by 1963 and felt ready by the summer of 1964 to tackle this particular seascape. The isles of Eigg and Rhum on the horizon seem like huge rock boats riding at anchor – the only solid forms between sea and sky. The artist said of this work: 'The sea yelled and I listened'.

38 *Reflections, Thurso Harbour, Caithness.* Water-colour, 24″ × 16″, painted 1965, exhibited F.B.A. Galleries 1966; tour of municipal galleries 1967; R.S.M.A. exhibition 1968; provincial galleries tour 1968, bought by Bertram W. Tawse, 1969.

A highly-detailed study showing the behaviour of water, quietly tranquil and touched with the palest of colour.

39 *Pulp Mill, Fort William.* Water-colour, 24″ × 16″, painted 1966, exhibited Industrial Artists' Group, Guildhall, 1966; tour of municipal art galleries 1966; F.B.A. Galleries 1968, provincial tour 1969.

This was not a commission but much like some of the work the artist was engaged on at the time. The background of the picture shows Ben Nevis – Britain's highest mountain.

40 *Temple of Vesta and Fortuna Virilis, Rome.* Charcoal, 16″ × 12″, drawn 1968.

Gunn has always had a special admiration for the Romans – their skill in design and engineering expertise that made their buildings last usefully for generations.

41 *On Ilmington Downs near Chipping Campden.* Charcoal, 17″ × 22″, drawn 1967, exhibited United Society of Artists 1968, bought by Mrs. Molly Newton, London, 1969.

A study of elm trees described by the artist as 'striding like delicate giants across the English scene'.

42 *Viking Landfall and the Pentland Firth.* Water-colour, 24″ × 16″, painted 1967, exhibited R.S.M.A., Guildhall, 1967; tour of municipal galleries 1968, reproduced in *History of the Clan Gunn*, by Dr. Mark Rugg Gunn, 1969, bought by Bertram W. Tawse, 1969, and presented by him to Lerwick Art Gallery, Shetland, 1970.

43 *Storm Clouds over Rhum, Morar.* Water-colour, 15″ × 10″, painted 1966, exhibited United Society of Artists 1966; R.S.M.A. 1966; tour of municipal galleries 1967 and 1968.

As in 46 (below) the artist has concentrated on sky effects, making apparent the differing ways that clouds behave over the sea and over land masses.

44 *An Teallach and Loch Droma, Ross-shire.* Water-colour, 24″ × 16″, painted 1967, exhibited United Society of Artists 1967.

The sketch for this was done at the same time as that for No. 28 (above) and is a view looking west, i.e. the opposite direction. Gunn was fascinated by the discovery that man-made structures not only alter the course of nature on the ground, as with artificially created stretches of water, but could have an effect on the weather as well.

45 *Cul Mor, Cul Beag and Stac Polly, Sutherland.* Water-colour 19″ × 15″, painted 1969, exhibited R.B.A. 1969.

Gunn has said that he felt these mountains had been transplanted from a foreign land and set down in Scotland – out of time and place.

46 *The Inverness Firth and Ben Wyvis.* Water-colour, 15″ × 11″, painted 1966, exhibited R.B.A. 1966, bought by Duncan MacLennan, London, 1968.

This small painting was based on sketches for a previously commissioned work.

47 *Bridport Harbour.* Indian ink, 26″ × 16″, drawn 1967, exhibited R.B.A. 1967; R.S.M.A. 1968, purchased 1968.

A grey boat, seen on a grey day, with oily reflections, lend themselves to indian ink and a black and white treatment. Here one craftsman (the artist) observes another craftsman (the man painting the boat). Soon after this work was finished Gunn completed his 6th Cosmic painting – *No World without End* – the differences in mood are striking, to say the least.

48 *Ocean Fugue, North Atlantic.* Water-colour, 33″ × 23″, painted 1968, exhibited United Society of Artists 1970.

This seascape of the Pentland Firth was inspired by an almost fatal sea trip in 1944. Nearly 25 years were to elapse before Gunn felt able to recreate in a painting the huge seas, which nearly drowned him.

49 *Ebb-tide, Bosham Moat, Sussex.* Water-colour, 24″ × 16″, painted 1967, exhibited United Society of Artists 1969.

The tidal margin at Old Bosham, and another study in what the artist has called his series *Harbours in Britain*.

50 *River Thames at Cheyne Walk, London.* Water-colour, 14″ × 10″, drawn 1969, exhibited municipal galleries, bought by Leamington Spa Art Gallery for the permanent collection.

Chelsea was one of the first parts of London Gunn came to know. His wife, Katharine, lived here before their marriage, in a flat overlooking the river.

51 *Plymouth Harbour, Devon.* Charcoal, 19″ × 15″, drawn 1969, exhibited R.S.M.A. 1969; tour of municipal galleries 1970/71 as part of *Cities of Britain* exhibition.

This work gave the artist much pleasure and charcoal seemed to him to be the right medium to capture the light and shade, the reflections and the 'velvet darks'.

52 *Ackergill Harbour, Caithness.* Water-colour, 19″ × 15″, painted 1969. exhibited R.S.M.A. 1969; tour of municipal galleries 1970.

The artist was particularly attracted by the way the boats were anchored to the shore by long ropes which accentuated the perspective effect.

53 *Braemore, Caithness.* Water-colour, 24″ × 16″, painted 1966, exhibited F.B.A. Galleries 1966, reproduced in *History of the Clan Gunn,* by Dr. Mark Rugg Gunn, 1969.

The conical mass of Morven overlooks the valley of Braemore, where once a thriving community of crofters lived. The few scattered houses remaining after the clearances are shown in the picture.

54 *Clachtoll Bay, Sutherland.* Water-colour, 19″ × 15″, painted 1969, exhibited United Society of Artists, 1969, bought by Philip Burns Esq., 1969.

The bay is hidden away on the road from Lochinver to Drumbeg and Gunn first 'discovered' it when making sketches for what became his first Cosmic painting.

55 *Via Sacra and the Arch of Titus, Rome,* 1968. Charcoal, 19″ × 15″, drawn 1968.

The fourth of the Rome series. The church of St. Cosmedin is in the middle distance to the left.

56 *Temple of Antoninus and Faustina, Rome,* 1968. Charcoal, 19″ × 15″.

The fifth in the Rome series. In ancient Rome this colonnade was the front of the Temple, now it is the rear excrescence of a renaissance church with the superstructure surmounted by a broken pediment.

57 *Forum Romanum,* 1968. Charcoal, 19″ × 15″, drawn 1968.

This is the third of a number of charcoals drawn during a visit to Rome in 1968. Each work includes the date in the title because, as the artist has stressed, ancient ruins change in appearance from year to year as they crumble away: but the drawing makes his lasting comment.

58 *Polperro Harbour, Cornwall.* Charcoal, 19″ × 15″, drawn 1970, exhibited R.S.M.A., Guildhall, 1970; tour of municipal galleries 1971.

59 *Woolston Creek, near Salcombe, Devon.* Water-colour, 19″ × 15″, painted 1970, exhibited F.B.A. Galleries 1970; tour of municipal galleries 1972.

A quiet backwater behind Salcombe and part of the Kingsbridge Estuary.

60 *Ullapool Pier, Ross-shire.* Water-colour, 19″ × 15″, painted 1970, exhibited at R.I. 1971, bought by Bertram W. Tawse 1972.

Gunn drew some of the plans for this pier, long before it was built in the form depicted in the water-colour.

Opposite: *No World Without End*

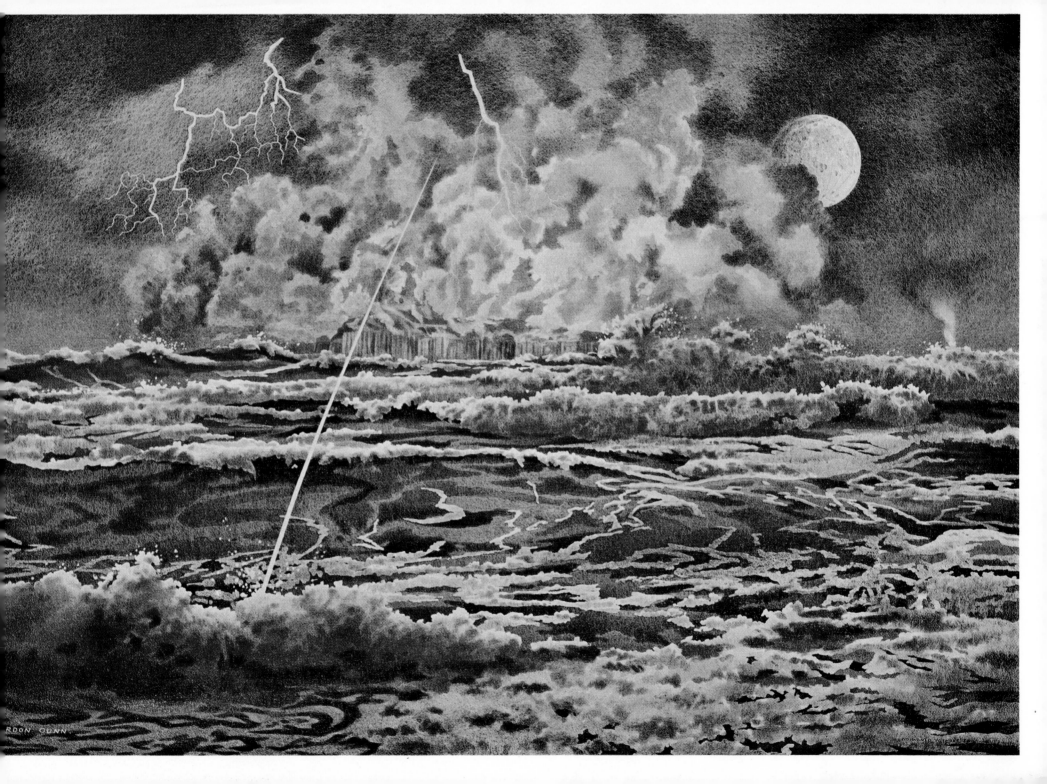

61 *Cliff-hanger*. Charcoal, 19″ × 15″, drawn 1970, bought by Andrew Watt, Esq., 1972.

This birch tree, gripping the edge of a steep mountain slope fascinated the artist with the rich contrast of light and shade in a subject tenacious of life in difficult circumstances.

62 *Silver Birch in Winter, Kent*. Charcoal, 16″ × 22″, drawn 1971, bought by Dr. Sylvia Gunn 1972.

A study of a silver birch at Knole Park, Sevenoaks.

63 *Surf on the Rocks, Huna, Caithness*. Water-colour, 15″ × 11″, painted 1970, exhibited R.S.M.A., Guildhall, 1971, presented to painter's wife, Katharine.

One of the farthest shorelines on the north of the Scottish mainland – the combination of sky, sea and rocks is typical of the area.

64 *The Seagull*. Water-colour, 15″ × 11″, painted 1971, bought by Mr. Dobson 1972.

On the grounds that artists should take advantage of all aids to perception Gunn drew this after looking at the gulls through a pair of binoculars.

65 *Sailing into Rye Harbour*. Water-colour, 15″ × 11″, painted 1971.

66 *Isle of Skye from Keppoch, Arisaig*. Water-colour, 15″ × 11″, painted 1971, bought by Mrs. Frank Lorimer 1972.

Gunn has known this scene in all weathers for more than half a century.

67 *Strathnairn*. Charcoal and wash, drawn and painted 1970, bought by D. Hammond Esq., London.

Finished from sketches made in 1969.

68 *On Bembridge Down, Isle of Wight*. Water-colour, 19″ × 15″, painted 1971.

APPENDIX 1

IDEAS AND TECHNIQUES IN COSMIC ART

by NIGEL GUNN *and* NEIL RHIND

IN discussing the technical aspects of any type of art it is important to recognise the extent to which such a discussion can be theoretical and to what extent it must be empirical.

Historians tracing cultural movements of the past have found it convenient to theorise, to bring into the field some rules of context whereby the diversified objects of study become more amenable to classification and general comprehension.

Such techniques are indispensable in the treatment of, say, renaissance painting, or other phenomena of the past which will remain static for scrutiny under modern analysis. In this way we discover common principles and cast light upon the differences that provide us with aids to recognition and interpretation.

In the case of cosmic painting, however, which as a conscious form is probably less than a quarter of a century old, we have a more hazardous and difficult task. No theoretical approach could be pursued properly until cosmic painting has run its course. Without the advantage of a retrospective view we are unable to draw generalisations from the possibly long and unpredictable historical chain to which it may give rise. Moreover, to lay down firm ideas on the subject might serve to cramp future developments as much as it would assist them. Turning to the empirical approach, we are inhibited by the sparsity of examples from which any overall view would have to be assembled at this stage. What follows then, is bound to be a compromise with many points subject to future revision and changes of emphasis. While cosmic art is still in the crucible, its transient and particular features cannot yet be fully separated from whatever elements within it may flourish and persist into the coming centuries.

Pictorially speaking, the cosmic painter is concerned to choose the disposition of paint on the surface of his paper, and the disposition of objects in the 'illusory' space depicted in the work. His problems will be rather different from those of, say, the straightforward landscape painter. The one essential feature of cosmic painting, around which this difference centres, is that of *relative scale*.

Branches of visual art such as landscape and portraiture are formed around what one sees with or without glasses. They are a pictorial rendering, a pictorial realisation, and thus make intelligible more or less common impressions or visual sensations. But cosmic painting 'sees' from distances numerically and quantitatively removed from 'normal' distances. When scale is present in a cosmic painting as a stylistic feature some of the images used may be microscopic or macroscopic. The distances which it uses as artistic pictorial distances between object and observer are distances which usually necessitate the use of microscope or telescope to make them intelligible and artistically useable. Though it is not always necessary for him to do so, the cosmic painter may make use of such additional aids to vision or understanding to facilitate the rendering of distances.

Works in the sublime manner, Salvator Rosa for example, or the trees in the paintings of Altdorfer, use the device of portraying unruly elements of nature on a larger scale than humans. Also, in Leonardo's *Deluge* drawings, or in the American artist Chesley Bonestell's *The Rains Came,* the simple amount of water is out of scale. These are the historical roots of the scale aspects of cosmic painting; which presses scale aspects still further until, as it were, the planet cannot contain them, and the sizes of extra-terrestrial bodies such as the moon, and distances to them, become involved. This may be called the defining feature of cosmic painting in the field of design – since it is relative scale which characterises most particularly the cosmic painter's attitude to space.

The design for a cosmic painting (or any other painting) will be bound to include a lot of extraneous material. It is, however, the conscious exclusion of as much extraneous material as possible that provides the main activity in the production of a cosmic design. The idea must be efficiently presented and be seen to work or have a meaning which is, or will be, significant to man.

The concept of 'space' to which cosmic painting subscribes is the traditional classical one, and the problem of 'space' in composition the cosmic painter sees as the problem of relating solids to a given space-depth, and to each other within that space. But whereas the painting

of solid objects has become an end in itself, the cosmic painter now looks upon solid objects as space in another form, just as matter is energy in another form. If we re-orientate our ideas about solids we begin to see matter as a sort of interruption of space volumes.

So, for the cosmic painter, composition is a cogent part of what he must have regard for when he is giving form to his ideas. Every 'solid' area in his work must suggest its lack of solidity its transmutability – and every space area must suggest its lack of 'spaceness'. There is an implicit, if not explicit, melding of the two; and a striving towards this end in every cosmic work. This is done by concentrating on the background against which both solids and space can occur. Terrestrial and celestial space are the chief concerns of the cosmic artist.

It is the background that is added in cosmic art to the considerations of composition. This new dimension can be either a space one, or it can be one of time. Juxtaposing events that occurred at different times so that special relationships will give rise to a new idea about either or both is one way of doing this. The cosmic painter, in short, tries to bring a fourth dimension into composition which hitherto only dealt with three. The harmony that exists between space and solids in a drawing is its 'balance'. An uneasy equilibrium, which can only be resolved by the use of one station point, from which the artist observes the behaviour of solids in space against the background of their existence, provides the compositional basis for a cosmic painting.

The *form* of an object (as opposed to its shape) is taken to be that quality in a picture which speaks back to us. It is as though the artist's mind was stretching out to us from his work, as though he actually communicates with us through special and universal symbols which can be echoed in most of us. In this way, the essence of an object can be communicated by recording its shape, colour and consistency so as to encourage us to respond to imaginary sensations.

The quality of the idea given form is the point on which it is necessary to dwell, for it is the type of energy that bounces back at us from a cosmic painting that is significant.

Let us accept for the moment that one of the jobs of the artist is to create an illusion of place; that is to help the observer feel that he really is in the environment depicted in the painting. If this is so, then it follows from what has been said of form that the artist will be unable to do this unless in some sense he endows the scene with a life which will be his own commentary upon it or, in other words, unless he is in some sense present in the scene he has depicted. This is easy enough to do in painting a straightforward landscape or a portrait, but what of a cosmic scene where the spirit of man does not appear to exist? This is the crux of the matter. Where the spirit of man does not exist the cosmic painter must make it exist, and he does this by so arranging his ideas about the scene that they become significant to man.

In practical terms this involves the use of significant lines and scale relations, or the deliberate re-juxtaposition of masses, so as to produce a fresh line of enquiry about the scene depicted or, in a scientific sense, about the universe as a whole. The manner in which this is brought about graphically is by giving form to a viewpoint which is known to be other than a normal visual viewpoint. This resulting cosmic viewpoint is, by its nature, one which makes visual sense as an illusion of objects in real space, but which the limitations of our senses or circumstances prevent us ever from reaching in our lives outside of art.

It is not difficult to trace the qualities above in Gordon Gunn's cosmic paintings illustrated here. *Before the Cataslysm* (cosmic painting No. 1) and *The Dying Sun* (cosmic painting No. 2) both feature celestial objects outside their normal contexts and in unfamiliar scale relations to the structures on the terrestrial surface. In both cases these distortions are not merely surrealist fantasies, for their unfamiliarity stems not from their inherent impossibility, but from the severe restrictions in the number and range of natural phenomena to which we have a chance to become accustomed in a short lifetime.

The Water World (cosmic painting No. 3) likewise places in the larger background of the astronomical space and time, the same earth with which we are familiar in a totally different way. Here also, and in *The Field of Mars* (cosmic painting No. 7) we noticed the absence of weight, the mysterious force which, though it is extremely localised, most of us take for granted. In *The Heart of a Rose* (cosmic painting No. 5) too, we enter a situation in which gravity plays little part. The forces at work here are the interactions of organic molecules in the machineries of living cells. We recognise that on the desert of inter-planetary space even this inarticulate form of life is man's close kin.

In each case the pictorial statement is representational and precise, and the rules of classical perspective are strictly adhered to. Because he is working in frames of reference which are strange to all of us (including himself), he must avoid at all costs clouding the issue with any strangeness of a purely subjective character. This is how he strives to create an eloquent and appropriate description of the extraordinary, through a clarity of style which will immediately convey its unambiguous message to every onlooker.

It is not possible, nor would it be desirable, for an artist to produce a purely objective copy of nature. His mode of expression must reflect his own personality and the standards of contemporary culture as well as bearing the stamp of individual craftsmanship. While a cosmic work could be said to have its origins in the physical realities of the cosmos, it is equally to be regarded as a human testament, made by human hand and mind to arouse interest and pleasure in others. The artist, although he may sometimes leave humanity out of his pictures, cannot leave it out of his thoughts. The aim is not to belittle human activities and values but rather to broaden and enrich them, showing the way past the commonplace things in the foreground of our lives toward some of the greater manifestations of this magnificent engine, the Universe.

Opposite: *The Field of Mars*

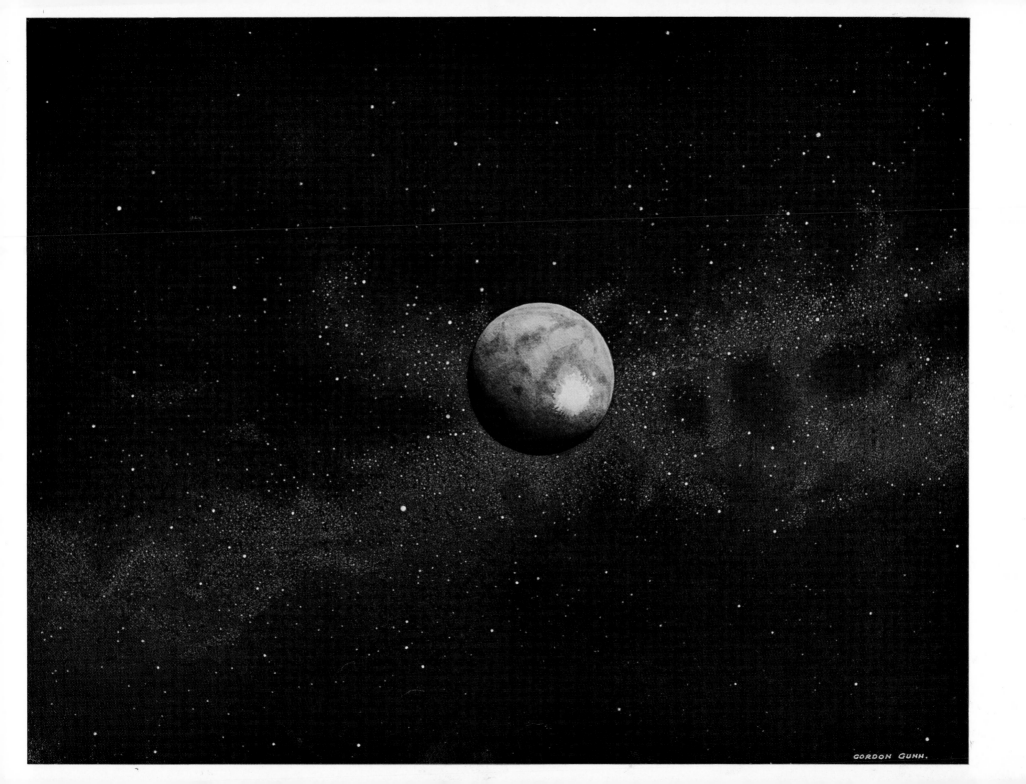
GORDON GUNN.

APPENDIX 2

TECHNIQUES AND MATERIALS

GORDON GUNN's work is distinctive for many reasons; one of these is the choice of medium – water-colour. Whilst no artist should be categorised by his medium but only by his skill and ability, there is no doubt that an artist who consciously chooses to paint almost entirely in water-colours in the mid-twentieth century excites some attention. It is not a question so much of fashion – for water-colour has long been an admired medium in the hands of British painters – but simply that the public for many years thought that 'serious' works could only be executed in oil paint.

Water-colour is of great antiquity, used by the Chinese as far back as known civilisation goes. And in the West, Dürer was probably the first artist of note to use it as a medium for making pictures, although water-colour had been used in various other ways before Dürer's time, on illuminated manuscripts, or mixed with plaster for frescoes.

For Gordon Gunn, water-colour seemed a natural choice. He had grown up with water-colours on the walls of his home, and although oil painting techniques were stressed at Art School, his own inclinations and the encouragement of his tutors set Gunn on the path he has followed ever since. He found the medium's scope wide, whether a work was to be a quick impression or the result of a spacious well-thought-out scheme, it could display colours with brilliant effect or in subdued tones.

But probably it was the medium's translucent qualities which appealed to the artist for the type of work and subjects he chose. The straight-forward wash technique is employed by Gunn, because it is the best way to express what he wants to say, and contributes to his work what has been described as liquid light. In a comment on the works of Turner, Gunn says: 'Turner's water-colours have been referred to as liquid light, and this is how I like to think of the medium. I like to think of rearranging light in this liquid state so as to produce another way of looking at things. To all life as we know it, light is the cosmos, for without it we could not live. To me, the art of water-colour is one of the best ways so far discovered of manipulating light'.

The viewer of Gunn's landscapes and cosmic paintings can see exactly what he means by the above statement, especially if he tries to imagine the same work in oils. The freedom and transparency, the spaciousness, and the almost dream-like quality of some of Gunn's paintings, could not have been created with anything like the same conviction in oil paint.

The materials

It seems a pity that whilst the artist is much concerned with the public's reaction to the finished work (ensuring only that the materials and tools are adequate for producing the picture), the public is just as curious about the clay with which the work of art was fashioned and the technique of moulding it. By examining the raw material we hope to gain insight into the workings of the artist's mind and analyse his creative processes. Most artists regard such interest as meddlesome and Gordon Gunn is no exception, although for this book he has been willing to talk about the materials he uses and his reasons for using them. At the same time he insists that such things are of no interest to outsiders and that a knowledge of his techniques will not necessarily work for any other artist or aspiring artists.

The paper

Gunn paints on boards prepared by himself, the surface consisting of a special water-colour paper handmade from linen fibre. This paper (Whatman) is of extra interest in itself, for it was made in 1914 and possessed such exceptional qualities that Gunn went to the trouble of tracing the manufacturer and purchased all the remaining stock.

The paper is stretched with a cellulose adhesive on to a pasteless board so as to provide a flat pre-stretched area which will not buckle while work is underway. And great care is taken not to rub the surface of the paper in its wet state or when dry – erasers are never used except occasionally a putty rubber to lighten a line drawn too heavily as a guide towards final intention.

Of his brushes it is enough to say that only the finest quality sable, and for special tasks ox-hair, which will taper to a knife-edge, are used.

Working on a prepared board has many advantages, for the finished work can be stacked behind acetate without damage and this, short of framing, solves many display problems. Thus, the artwork can be made extremely durable and if properly treated can survive for centuries.

The colours

Gunn, as has been said before, works mainly in water-colour and although he does this out of preference for the medium, his choice was partly dictated by technical advance and improvements in the manufacture of the pigments. Until the beginning of this century many of the pigments used were found to be sensitive to light and fugitive. But in recent years improvements in the making and the development of techniques in putting the colours on to paper or board has resulted in art work which will last as long as any other artistic medium and, in some cases, much longer.

Gordon Gunn carried out his own experiments in pigment exposure to light. Some of his paintings have been hung in positions where direct sunlight has shone on them daily for over thirty years yet they show no signs of fading.

Water-colour consists of finely-ground pigment with a small proportion of binding medium, such as gum. This thick glutinous material is thinned down with clean, fresh, warm water, and floated on where required. Gunn uses a minimum of 8 saucers of colour mixes when he is painting, always using tube colours because they are at all times moist and unsullied.

He never uses primary colours on their own, always adding a touch of another colour to avoid the commonplace or strident tone. After all, nature's colours are seldom found in a tube of manufactured paint – nuances of shade are to be found everywhere. For example, if a red carpet were rolled out to the horizon, it would not look the same colour, or even tone, for more than a foot along its length.

The paper supplies any white surface needed, for one of the supreme properties of water-colour is its translucence. Thus, Gunn never uses white, unless working on a tinted board or aiming for a special effect. Also, he never uses black. This might surprise the viewer of his paintings but any areas which seem black have, in fact, been built up by numerous washes, each wash adding to the velvet darkness required.

The studio

The possession of a well-appointed studio and a welter of equipment is an advantage for the serious artist – but numerous tools of a trade are not in themselves necessary for the production of a work of art, or an indication of talent. A scrap of paper and a crayon in the hands of a Rembrandt is sufficient for him to distil for us a vast block of life's experience. Nevertheless, the true artist will find time wasted if he does not have to hand everything required for his craft.

Gunn has maintained studios in his south London home and in Inverness, for many years. He prefers to work at a drawing board (although he regards an easel as essential) and keeps good stocks of all he needs, down to drawing pins. And for this artist especially, there are three important aids to perception – binoculars, a telescope and a microscope.

Methods

To many, analysis of an artist's methods and watching him at work, is an all-absorbing pastime. But to Gordon Gunn, such an interest is akin to watching a builder mix cement and put one brick upon another, or a surgeon removing infected tonsils. To him (Gunn) it is the end result that matters – not the technique used to do the job.

It is not easy to describe an artist at work and even discussion with him seldom reveals all the interviewer hopes for, as much of the chemistry of technique cannot be analysed, for it comes to the artist as second nature and without a conscious thought. Ask him to rationalise and explain and he can only wave at an example of his work when it is finished.

But unlike the surgeon or bricklayer, the artist can experiment, especially the painter using colours and paper, for then it is only time that is valuable. We can look at the sketches, the notes, and finished work and draw what conclusions we may.

Gordon Gunn attributes much to a well-trained memory. When painting a seascape, for example, Gunn will recall details of the sea from the past when he has spent time on it or beside it, simply looking and absorbing details of colour and textures and the way water behaves. Thus, his experience of the sea will be applied to a particular seascape and it will be a better seascape because of it. Memory training is

Opposite: *Hyperion's Way*

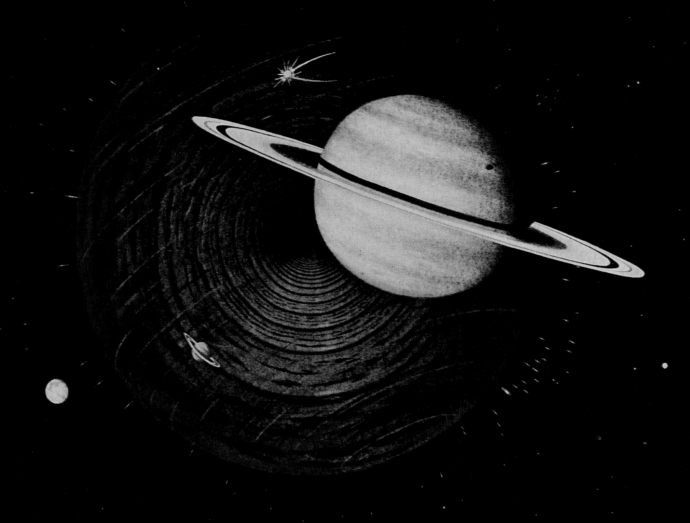

perhaps the most important discipline that the artist must acquire.

In addition, Gunn finds that when he looks at the sea or a landscape, a pattern must emerge before he commits anything to paper – a few lines will suffice. Then the rough outline is superimposed, with more detail, on tracing paper, until a reasonably convincing rendering has been produced.

In the studio, the basic framework will gradually become a completed black and white drawing which not only reminds the artist of the scene but has the quality of making him and others feel that they are actually there.

The water-colourist has to depend more than most artists on preliminary sketches in black and white. If he does not prelude his finished works with a work-out in sketch form he has to rely solely on memory. This may suit the man working as an impressionist but there is the risk of sterility if he continues too long to pastiche himself. The sketch book becomes the stock in trade and many fine works have been produced from sketches of considerable vintage. One of Gunn's sketches, made when he was sixteen years old became a large painting 26 years later.

The sketch block can be used to record information – notes on time, colour, even the geophysical conditions the artist sees at the time. For working in the field, painting direct from nature, has its drawbacks, especially in the Scottish Highlands – where the artist with easel and board must battle against the elements and the changing light more than his counterpart who chooses to find inspiration in a Mediterranean fishing village.

Until the black and white sketches are finished colour plays only a small part in the process. The artist, if the conditions are ideal, can return to the place of the subject, but if that is not possible then he must return to the studio and rely on notes and memory.

In the past Gordon Gunn would produce trial runs in colour, because the master copy was made in Indian ink and therefore indestructible and as many copies as required could be produced. But once the final work is committed to the board the master sketch can be discarded. Gunn does not keep these unless they have something individual to say – one, indeed, was acquired by the Leamington Spa Art Gallery. But as his skill and facility grew Gunn found that he needed less and less to do these trial runs and now it is unusual for him not to go direct to the finished work from his master sketches.

This method of working may give the impression of a lack of immediacy, but for Gunn at least, it does not in so far as his freewill is not impeded, and that is the important thing.

For example, no one could say that the cosmic paintings lack spontaneity. In fact, the preliminary sketches, collages, and even models, take much time to execute before the original idea is given adequate form. Before the first sketches for the 7th Cosmic painting (*The Field of Mars*) a model was made of the planet based on as much evidence as could be discovered. This model was suspended in a darkened room and a bright spotlight took the place of the Sun. More consultations of the star atlas followed and there were walks under the night sky at Inverness, far from city lights which affect the intensity of star light. Sketch after sketch followed, until a final draft was ready for transfer to the finished board.

Cosmic paintings and water-colour

Gordon Gunn learned by experience that water-colour proved for him the best medium for cosmic and landscape painting. The night sky could not be properly portrayed by applying one heavy wash of dark pigment – the result is inevitably a dense mess – mainly because the darkness depicted is the result of a lack of light rather than the presence of a solid mass. Atmosphere and translucence must be achieved even though shades might be very dark indeed. *The Transmutron* and *The Heart of a Rose* (Cosmic paintings 4 and 5) might have been painted in another medium, but Gunn felt that the evanescent dreamlike effect he wanted in No. 4, and the waxy texture required for No. 5, all guided him towards water-colour.

This does not mean that cosmic painting cannot be done in any other medium. There are already some works in the genre in both oil and tempera, and executed with great effect, as in the cases of Bonestell and Pešek. But each work raises its own technical problems which have to be solved in their own special way for the best results. The artist will be drawn to have regard only for problems which can be solved in the medium most suited to his own individual predilection.

Nevertheless, the medium is part of the means which will determine the end result – and if the end result calls for water-colours, oils, tempera, casein, mezzotint, or scraps of old newspaper, then the artist makes his choice accordingly.

Other Media

Many of those who appreciate Gunn's work have been drawn initially to the works executed in Indian ink and charcoal.

Indian ink drawings can be either the means to an end or an end in themselves. If Gunn decides that the finished work is to be black and white in ink, then he works direct on to tracing paper prestretched on board. He is attracted to the smooth ivorine surface of the paper and it has the added advantage that it will take much punishment. The eraser can be used to achieve broken line effects and something close to half tones. Occasionally the work may be finished by adding washes of Indian ink diluted with distilled water. This has the advantage of not only being permanent but will also, when properly dried, even withstand damp.

Charcoal is a once only medium and the artist must be sure of his line for mistakes cannot be eradicated, except that light lines can be removed by a putty rubber, and dark lines be lightened somewhat. The medium is well suited to portraits; Gunn uses it primarily for trees. He enjoys using the medium to show the textures of ancient structures and derives much pleasure from seeing the velvety lines forming the desired shapes.

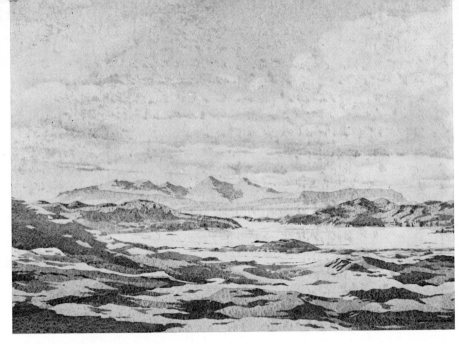

1. *Eigg and Rum from Ardtoe: Moidart.*

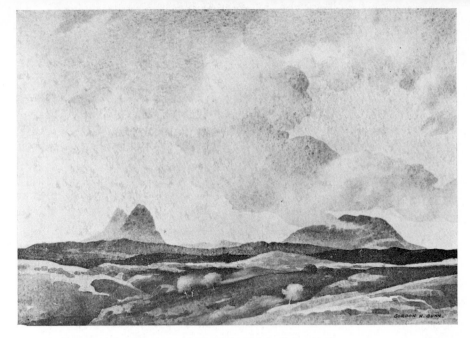

2. *Suilven and Col Mor from above Achmelvich: Sutherland.*

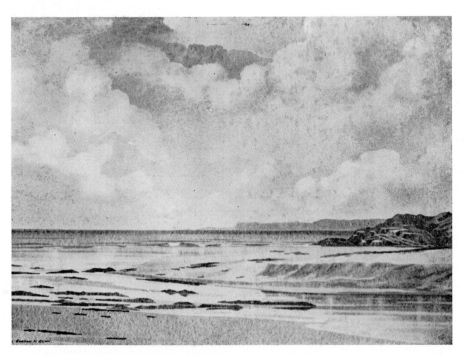

3. *The Point of Sleat from South Morar.*

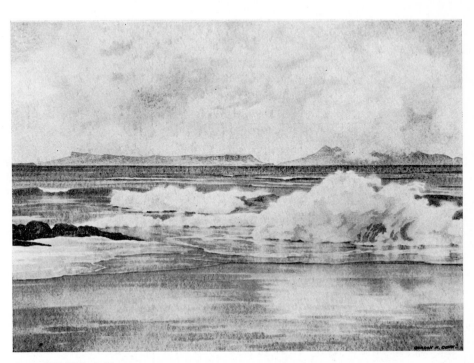

4. *West Wind: Morar.*

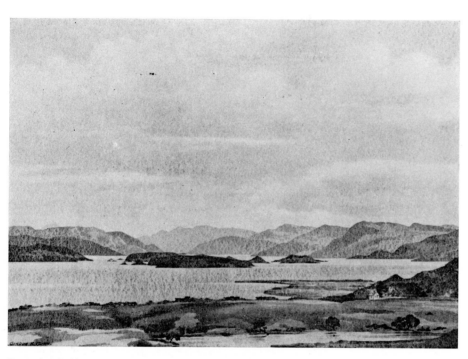

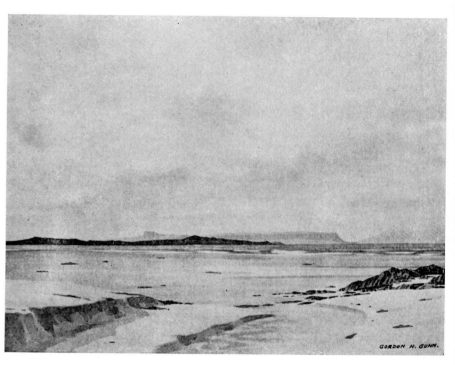

5. Loch Morar.

6. The Wide Strand.

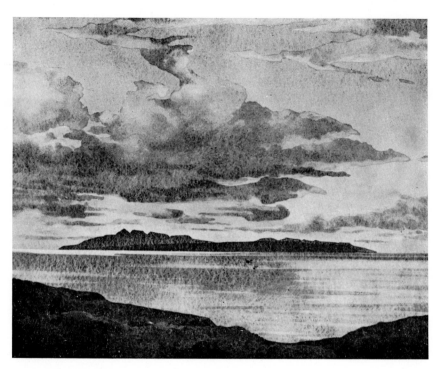

7. *Rum from Elgol.*

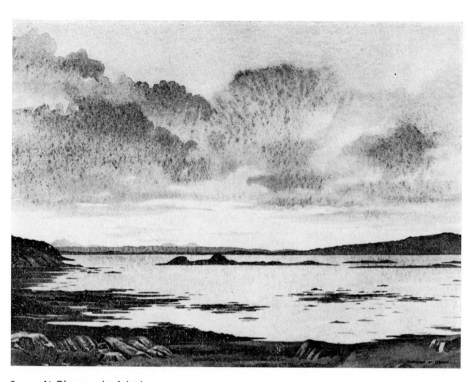

8. *At Rhuemach: Arisaig.*

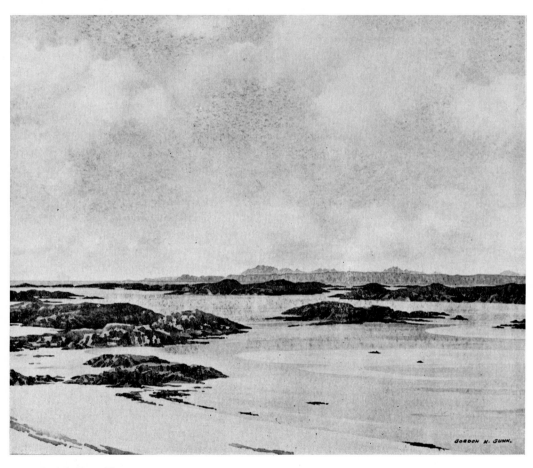

9. *Traigh Bay: Morar.*

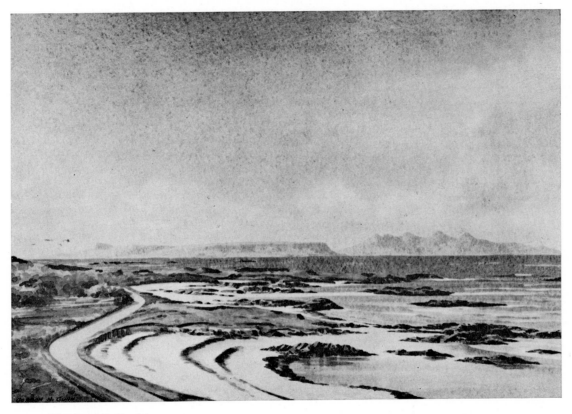

10. *The Road to the Isles.*

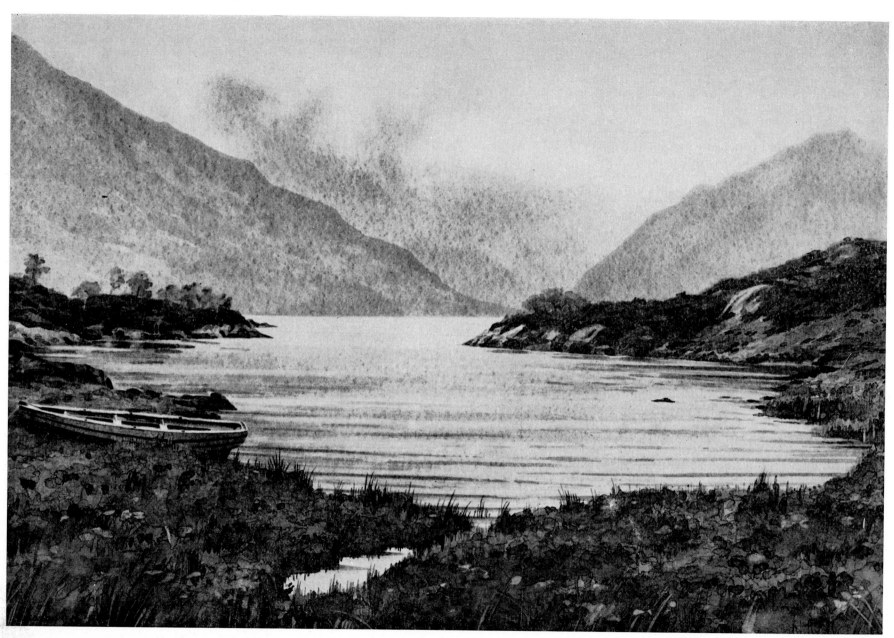

11. *Kinlochmorar.*

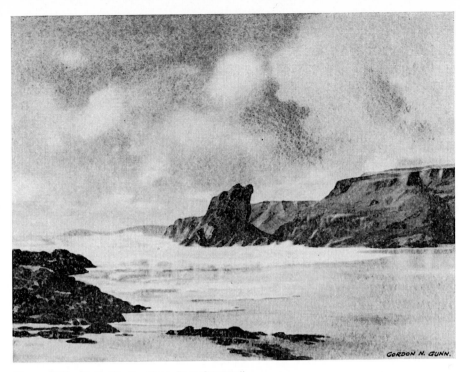

12. Will's Rock: Porthcothan Bay: Cornwall.

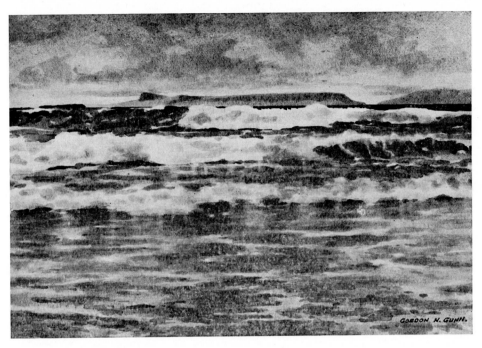

14. Sunset over Dornoch.

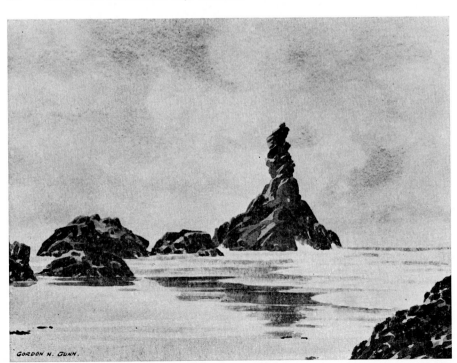

13. Queen Bess Rock: Bedruthen Steps: Cornwall.

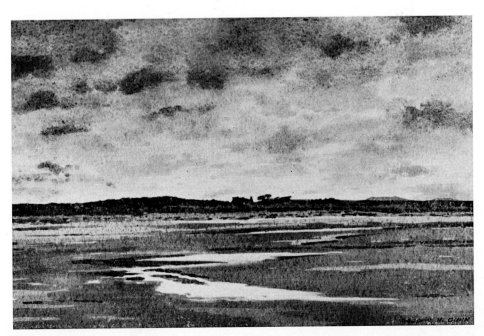

15. Incoming Tide: Morar.

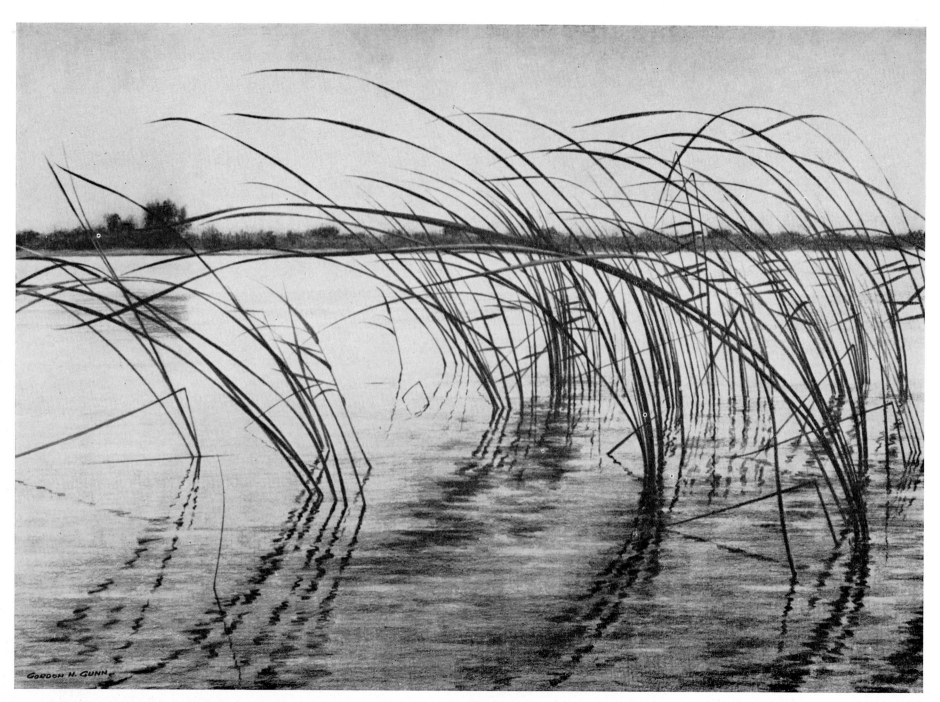

16. *Reeds and Reflections: Rollesby Broad: Norfolk.*

17. *On Patching Hill: Sussex.*

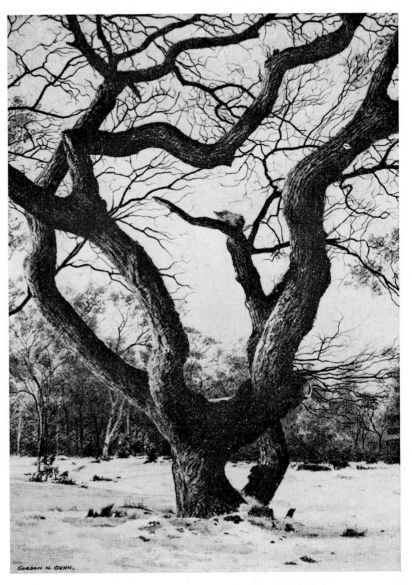

18. *Winter Study: West Heath: Kent.*

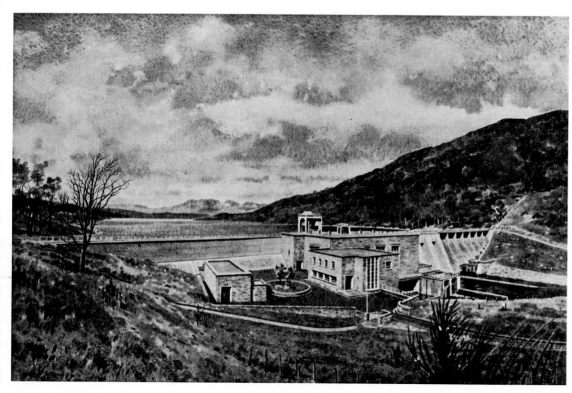

19. Torr Achilty Dam: Ross-shire.

20. Orkney and the Pentland Firth from Thurso.

21. Corries Point: Loch Ness.

22. *Robots at Bay: Bowaters: Kent.*

23. *Gravesend Canal Basin: Kent.*

24. *Glascarnoch Dam: Ross-shire.*

25.　*Mallaig Harbour: Inverness-shire.*

26. *Mousehole: Cornwall.*

27. *Study of Trees near Patching: Sussex.*

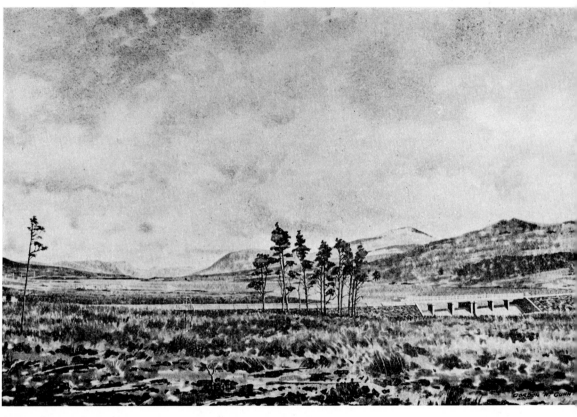

28. *Droma: Ross-shire.*

29. *On Ramsgate Slipways: Kent.*

30. *Eynsford: Kent.*

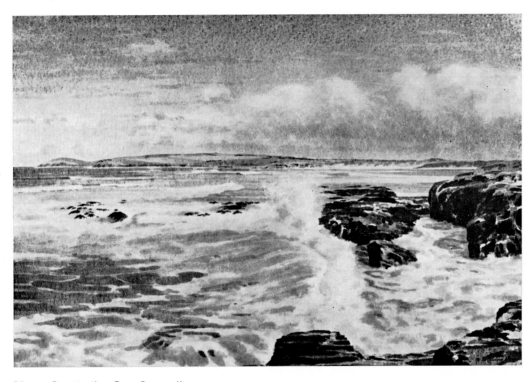

31. Constantine Bay: Cornwall.

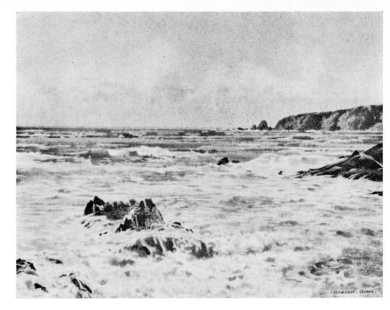

32. Thurlestone Bay: Devon.

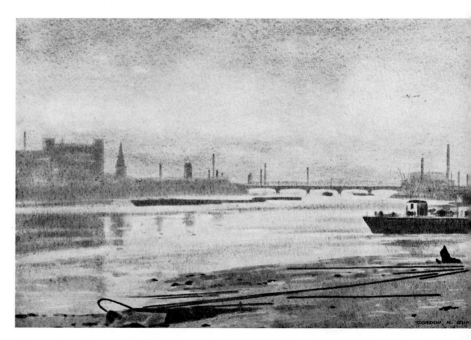

33. River Thames at Chelsea.

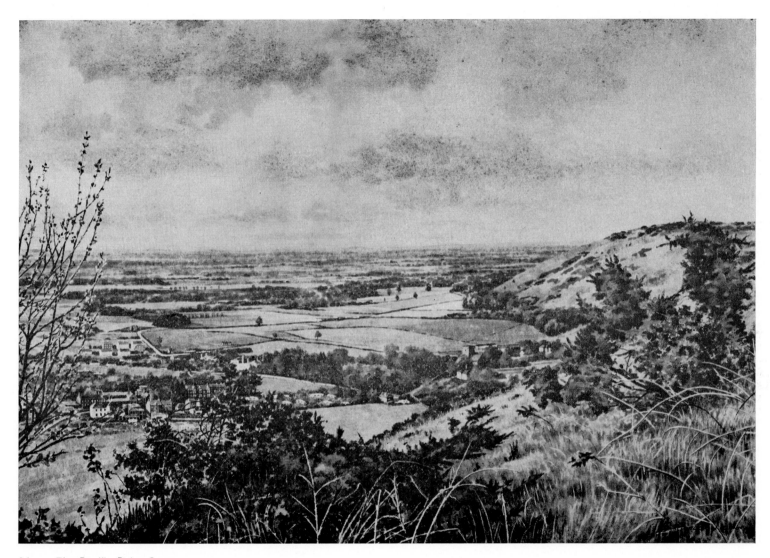

34. *The Devil's Dyke: Sussex.*

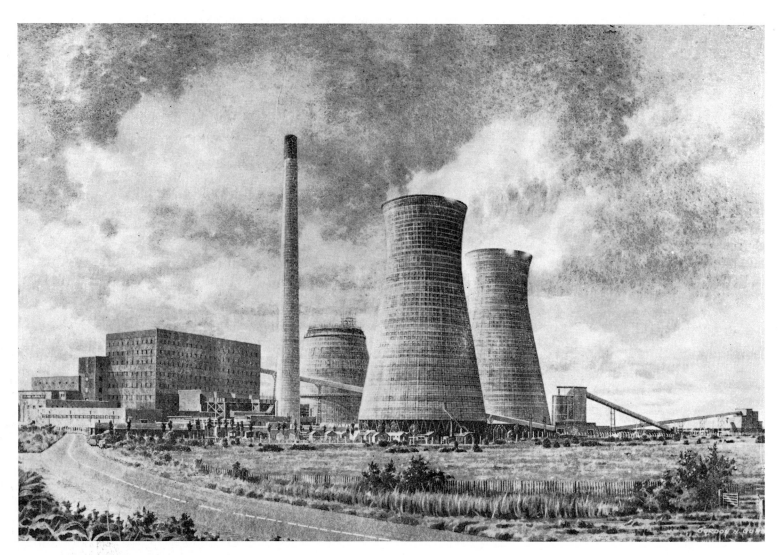

35. *Richborough Generating Station: Thanet.*

36. *The Cotswolds: Broadway.*

37. *The Sea of the Hebrides.*

38. *Reflections: Thurso Harbour: Caithness.*

39. *Pulp Mill: Fort William.*

40. *Temples of Vesta and Fortuna Virilis: Rome: 1968.*

41. *On Ilmington Down near Chipping Campden.*

GORDON GUNN.

42. *Viking Landfall.*

43. *Storm Clouds over Rum: Morar.*

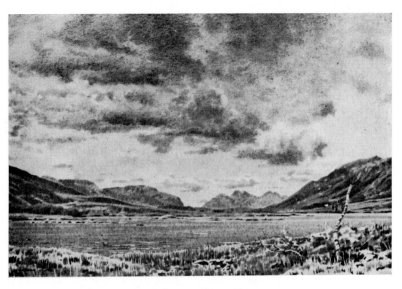

44. *An Teallach and Loch Droma: Ross-shire.*

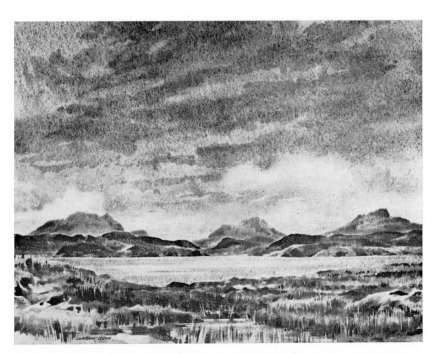

45. *Cul Mor, Cul Beag and Stac Polly: Sutherland.*

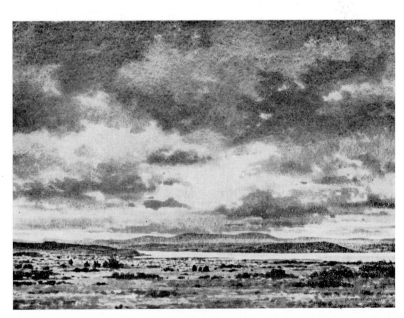

46. *The Inverness Firth and Ben Wyvis.*

47. *Bridport Harbour.*

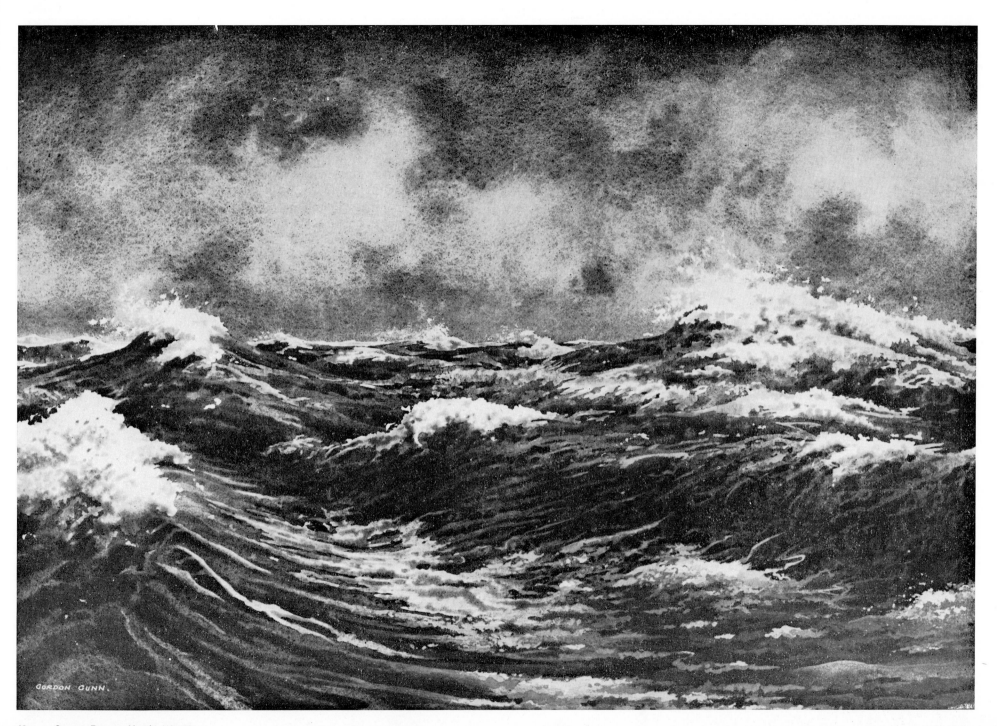

48. *Ocean Fugue: North Atlantic.*

49. *Ebb-Tide: Bosham Moat: Sussex.*

50. *River Thames at Cheyne Walk: London.*

51. *Plymouth Harbour: Devon.*

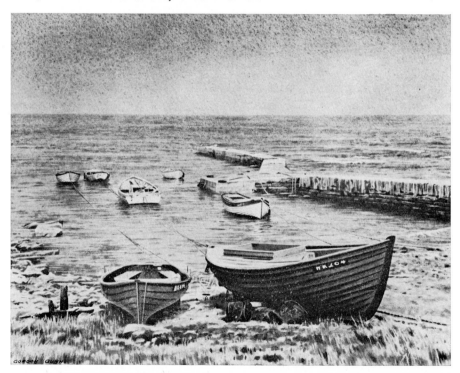

52. *Ackergill Harbour: Caithness.*

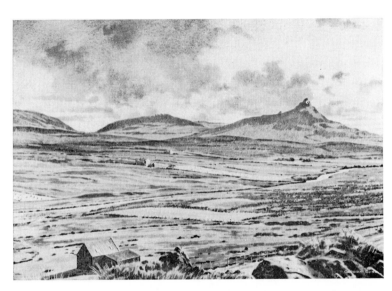

53. *Braemore: Caithness.*

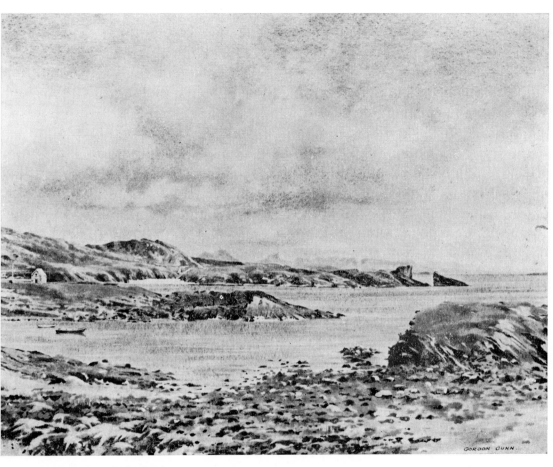

54. *Clachtoll Bay: Sutherland.*

55. *Via Sacra and The Arch of Titus: Rome: 1968.*

57. *Forum Romanum: 1968.*

56. *Temple of Antoninus and Faustina: Rome: 1968.*

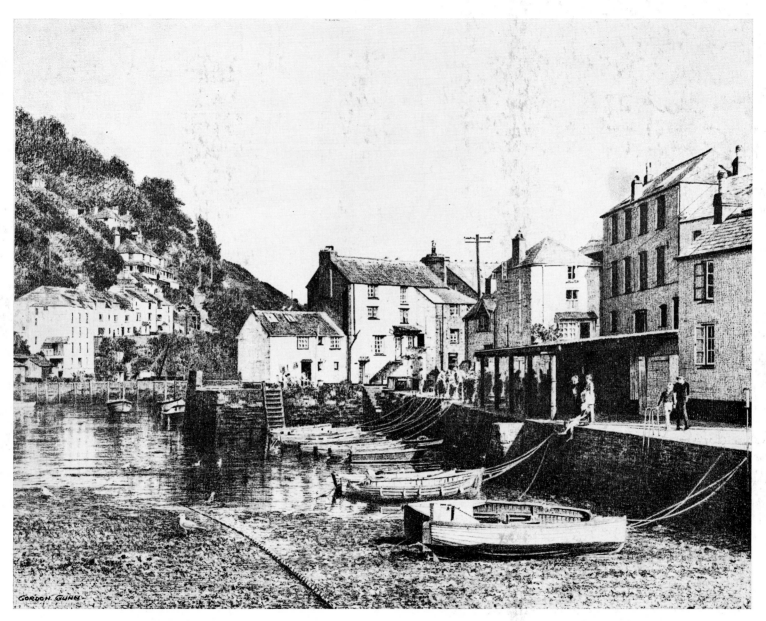

58. *Polperro Harbour: Cornwall.*

59. Woolston Creek; near Salcombe: Devon.

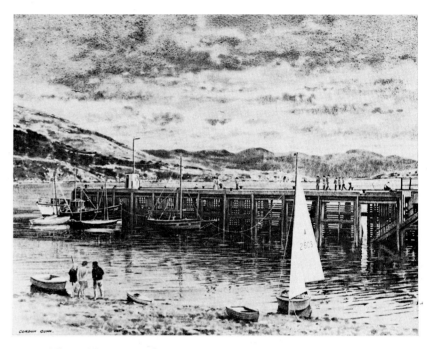

60. Ullapool Pier: Ross-shire.

61. *Cliffhanger.*

62. *Silver Birch in Winter: Kent.*

63. *Surf on the rocks of Huna: Caithness.*

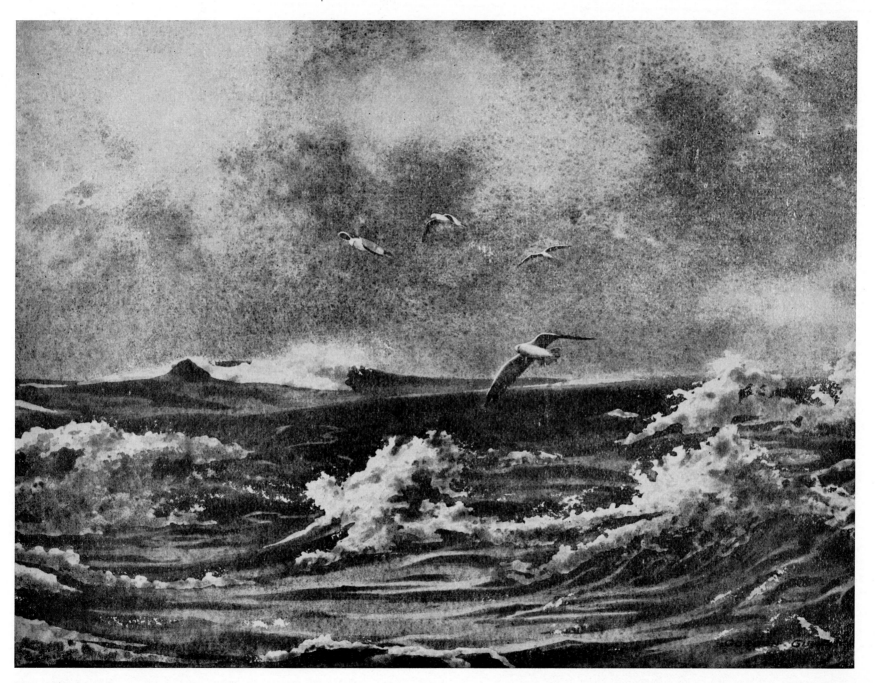

64. *The Seagull.*

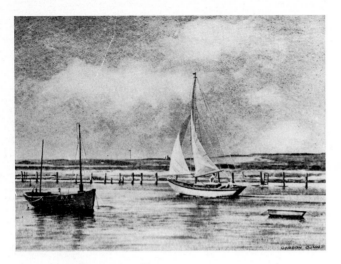

65. *Sailing into Rye Harbour.*

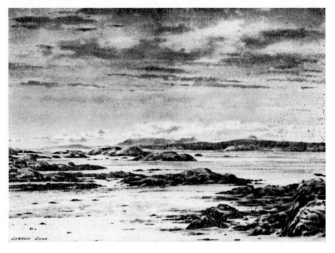

66. *Isle of Skye from Keppoch: Arisaig.*

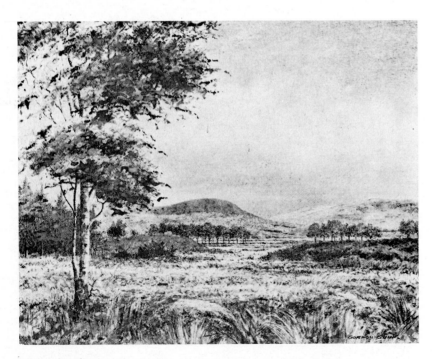

67. *Strathnairn.*

68. *On Bembridge Down: Isle of Wight.*